D1438212

Learn to Paint

SKETCH

Alwyn Crawshaw

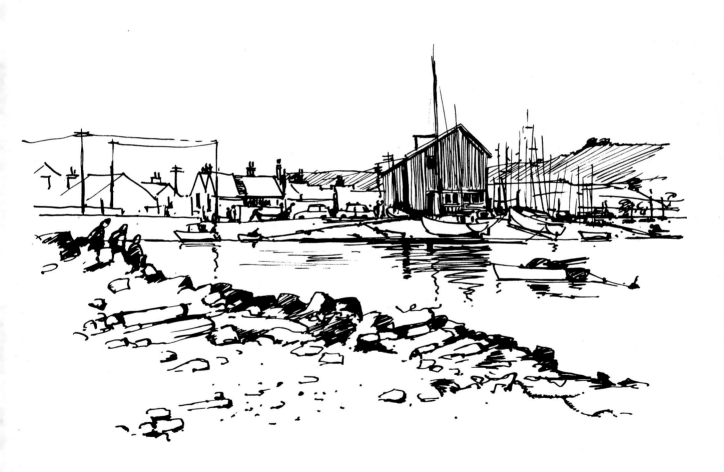

HarperCollinsPublishers

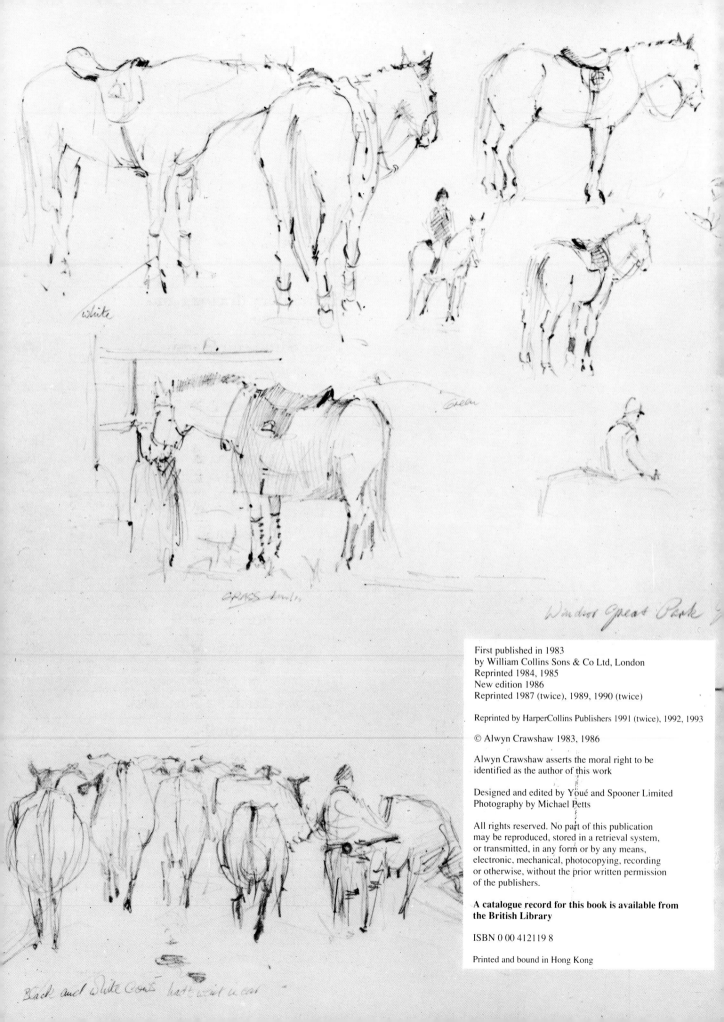

First published in 1983
by William Collins Sons & Co Ltd, London
Reprinted 1984, 1985
New edition 1986
Reprinted 1987 (twice), 1989, 1990 (twice)

Reprinted by HarperCollins Publishers 1991 (twice), 1992, 1993

© Alwyn Crawshaw 1983, 1986

Alwyn Crawshaw asserts the moral right to be
identified as the author of this work

Designed and edited by Youé and Spooner Limited
Photography by Michael Petts

**A catalogue record for this book is available from
the British Library**

ISBN 0 00 412119 8

Printed and bound in Hong Kong

CONTENTS

SKETCH OF AN ARTIST
ALWYN CRAWSHAW

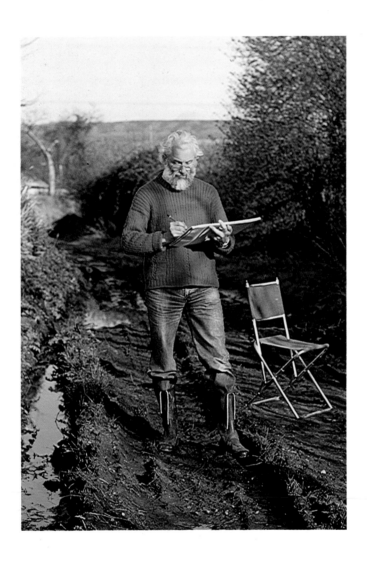

Successful painter, author and teacher, Alwyn Crawshaw was born at Mirfield, Yorkshire and studied at Hastings School of Art. He now lives in Dawlish, Devon with his wife June where they have opened their own gallery. Alwyn is a member of the Society of Equestrian Artists and the British Watercolour Society, a Fellow of the Royal Society of Artists, and is listed in the current edition of *Who's Who in Art*. His work has brought him recognition as one of the leading authorities in his field.

Alwyn works in all four main painting media – oils, watercolours, acrylics and pastels. He chooses to paint landscapes, seascapes, buildings and anything else that inspires him. Heavy working horses and elm trees are frequently featured in his paintings and may be considered the artist's trademark.

This book is one of eight titles written by Alwyn Crawshaw for the HarperCollins *Learn to Paint* series. Alwyn's other books for HarperCollins include: *The Artist at Work* (an autobiography of his painting career), *Sketching with Alwyn Crawshaw*, *The Half-Hour Painter*, *Alwyn Crawshaw's Watercolour Painting Course* and *Alwyn Crawshaw's Oil Painting Course*.

Alwyn's best-selling book *A Brush with Art* accompanied his first 12-part Channel Four television series. A second book, *Crawshaw Paints on Holiday*, accompanied his second 6-part Channel Four series, and *Crawshaw Paints Oils*, is the third Channel Four television

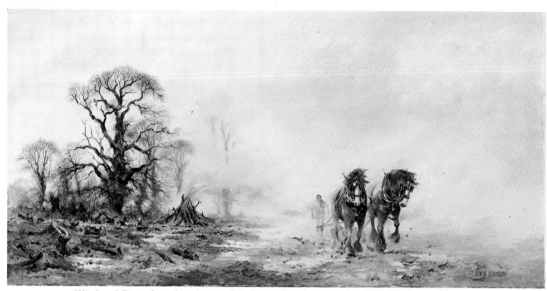

Wind and Fire, 38 × 76cm (15 × 30in). Reproduced as an artist signed limited edition of 500
copies in 1982 by Miss Carter Publications

series with a tie-in book of the same title. In addition, Alwyn has been a guest on local and national radio programmes, and has appeared on various television programmes. Alwyn has made several successful videos on painting and in 1991 was listed as one of the top ten artist video teachers in America. He is also a regular contributor to *Leisure Painter* magazine. Alwyn organises his own successful and very popular painting courses and holidays as well as giving demonstrations and lectures to art groups and societies throughout Britain.

Fine art prints of Alwyn's well-known paintings are in demand worldwide. His paintings are sold in British and overseas galleries and can be found in private collections throughout the world. Painted mainly from nature and still life, Alwyn's work has been favourably reviewed by the critics. *The Telegraph Weekend Magazine* reported him to be a landscape painter of considerable expertise and described him as 'outspoken about the importance of maintaining traditional values in the teaching of art'.

Sidmouth, Devon, 18 × 25cm (7 × 10in). Acrylic colour, private collection

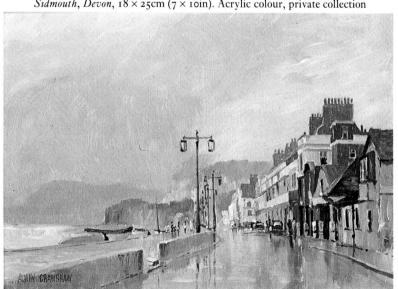

SKETCHING

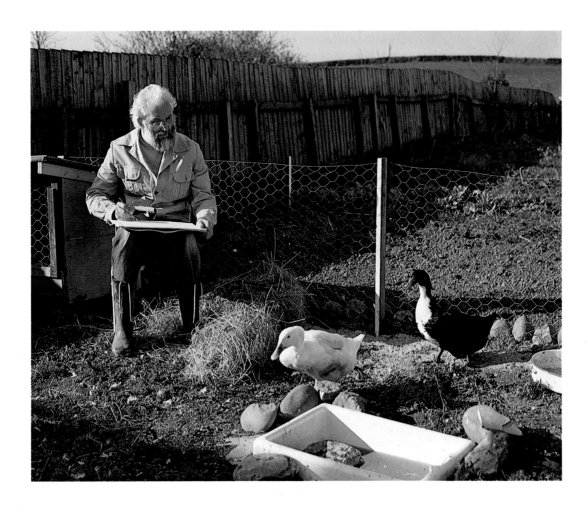

The sketch is the beginning. Almost all work that has been created on paper, canvas, clay, stone, metal, or indeed any artists' medium, started as a sketch. An idea can be stimulated by a thousand things, but a sketch can hold it for all time and be used as a foundation for other work, even though the idea may represent only a fleeting moment of inspiration. Sketching is a means of recording something forever. Therefore I feel strongly, and I repeat several times throughout this book: *never throw a sketch away, no matter how small or insignificant you think it is*. You have created something that is unique and original from which you can always learn, even years later.

If we accept that the sketch is the beginning, then we can also accept that sketching can be one way of learning to draw and paint finished pictures. In this book I want to teach you how to sketch out of doors and how to use your sketches either as works in their own right or as training exercises for drawing and painting. This will enable you to build on the knowledge you already have, or if you are a beginner, will open your eyes to new sights that can be

experienced only when you look around you with sympathetic and observant eyes. You will 'see' things in a new light. You could look at a telegraph pole and wonder at its beauty! Perhaps when you reach this stage, you should keep your thoughts to yourself for a while. Although people often think that artists are a little different (but I hasten to add we are not), placing a telegraph pole on a pedestal would have to stretch their imagination!

It is interesting the way we always tend to think of ourselves as the normal ones whatever profession, sport or pastime we indulge in. On one occasion when I went sketching to gather material for this book, I ended up at Exmouth. My wife, June, was with me and it was very cold. We walked along the banks of the river Exe estuary and around a small headland looking for a sketching spot. The sea was very shallow in this area and covered with wind-surfers skimming across the water. They were falling in, getting up, and falling in, over and over again. Although they had wet suits on, they looked extremely cold – we thought they were mad. Further along we saw two bundles

of clothing on the stony beach with what looked like long antennae sticking out. When we were closer a head peeped out and said: 'Good afternoon'. They were anglers, fishing quite merrily on such a bleak day. We acknowledged them and went on.

Eventually I found a suitable spot to put my chair down and started to sketch the scene in front of me. The wind was so biting that I was only able to keep it up for about 20 minutes. June had gone for a walk to try to keep warm. When I had almost finished, one of the fishermen came over to me and looked at my right hand blue with cold, and my left hand with a glove on, and said: 'You must be mad sitting out here drawing a picture.' The strange thing is that I had assumed I was the normal one and that the anglers and wind-surfers were the odd ones. So perhaps being odd is only in the eyes of the beholder. The sketch I did on that occasion was drawn with a 2B pencil on cartridge paper (see page 7, **fig. 2**).

I am not suggesting you go out and find the coldest spot and stick it out for 20 minutes. What I want you to be able to do after reading this book is go out with confidence and *enjoy* sketching. Incidentally I enjoyed doing the Exmouth sketch, but I still can't understand the wind-surfers!

I enjoy sketching just as much or even more sometimes than sitting in my studio painting a 'masterpiece' (my interpretation!). One of the greatest advantages of sketching is that it provides a reason to go out and enjoy your surroundings, even if it is simply to your own garden. The photograph on page 6 shows me in my garden sketching two new additions to the family. The ducks were given to us by our daughter, Donna, and her husband for our 25th wedding anniversary. The resulting sketch can be seen on page 23.

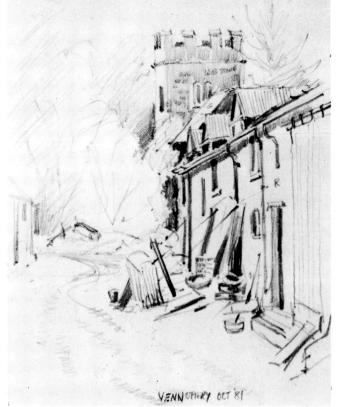

Fig. 1 *Venn Ottery Church*, 25 × 18cm (10 × 7in)

I have tried to write this book in a logical order but there is so much to say almost at the same time that it can be difficult. For instance, which comes first, the section on design or notes on perspective, how to use a pencil or what types of sketch to do, etc.? To overcome this I suggest you read the book through first even though at times it may seem as though the cart is being put before the horse!

All the sketches in the book, except for the exercises are reproduced from my sketchbooks. They were *all* done on

Fig. 2 *Exmouth – a cold day*, 23 × 30cm (9 × 11in)

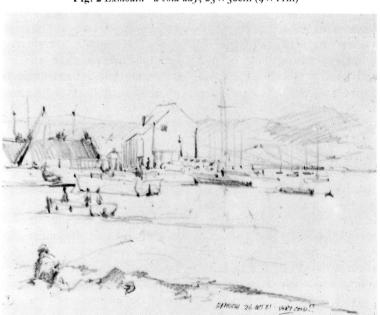

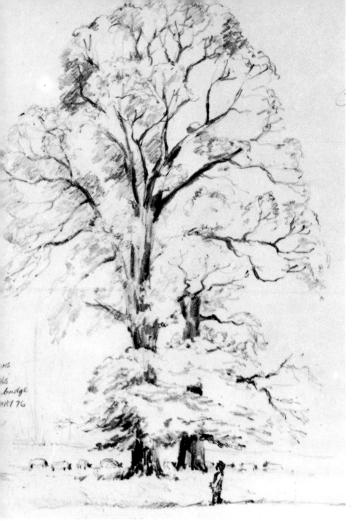

Fig. 3 *Twin Elms, Cambridge*, 28 × 22cm (11 × 8½in). In this sketch the information I was after was of trees, and I simply indicated their scale with the sheep and the figure

Fig. 4 *Me in bed*, 22 × 28cm (8½ × 11in). A typical enjoyment sketch

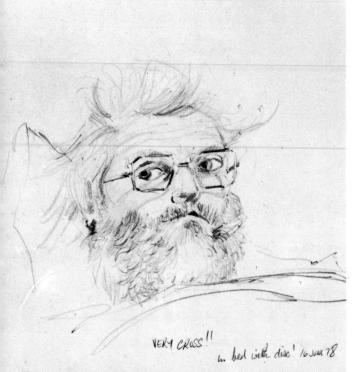

VERY CROSS!!

in bed with disc! 16 JUNE 78

location, some especially for the book, others from my work over the past few years. This should give a broad 'picture' of sketching and a variety of subjects. In fact each sketch tells me a story. I feel as though I am opening the pages of my private sketching life and sharing it with you, but by doing so you will be learning from my experiences.

Now let's get back to the drawing board. We know that a sketch is the beginning, but what is meant by the word sketch? Artists use it in so many different ways. A quick sketch can mean anything from something carefully observed and created with only a dozen lines, to a picture that hasn't made the grade in the artist's eyes, and *he* suggests: 'It's just a quick sketch!' One person can have simply a pencil and small sketching pad, and inform us that he is going sketching, while another could take everything he can think of: easel, canvases, paints, seat, small table, umbrella, etc., and yet still use the phrase: 'I am going out sketching'. I have found that usually this simply means, to go out and *draw or paint a picture*. In fact, I often use the same expression myself, and I might end up with a finished watercolour painting instead of a watercolour sketch. But, as we are interested in sketching with its 'real' meaning, I have defined the word, from the artist's point of view, to help you through the book. After a lot of careful thought I have broken down the sketch into four distinct and practical types:

Enjoyment sketch A drawing or painting worked on location, done simply to enjoy the experience.
Information sketch A drawing or painting done solely to collect information or detail, which can be used later at home or in the studio.
Atmosphere sketch A drawing or painting worked solely to get atmosphere and mood into the finished result. It can then be used later for atmosphere and mood information, or as inspiration for an indoor painting.
Specific sketch A drawing or painting done of a specific subject to gather as much information of detail and atmosphere as possible, which also conveys the mood of the occasion. The sketch is used as the basis for a finished studio painting. The specific sketch is really a combination of the information and atmosphere sketches, but the only difference is that the object is to go to a *specific place* to record what you see and feel, and then use all the information for a larger studio painting.
All sketches, whether they are drawings or paintings, can be used as 'finished' works; in fact, some artists' sketches are preferred to their finished paintings.

Let us now look in more detail at these different types of sketches. As each one has its own special purpose, before you go out you may have a preconceived idea of what type of sketch you are going to do. If you haven't, then go out and do an *enjoyment sketch*. Get together your sketching equipment and set off, looking at your surroundings with your sketchbook in hand. You have the perfect excuse to wander around and soak in the atmosphere or the visual

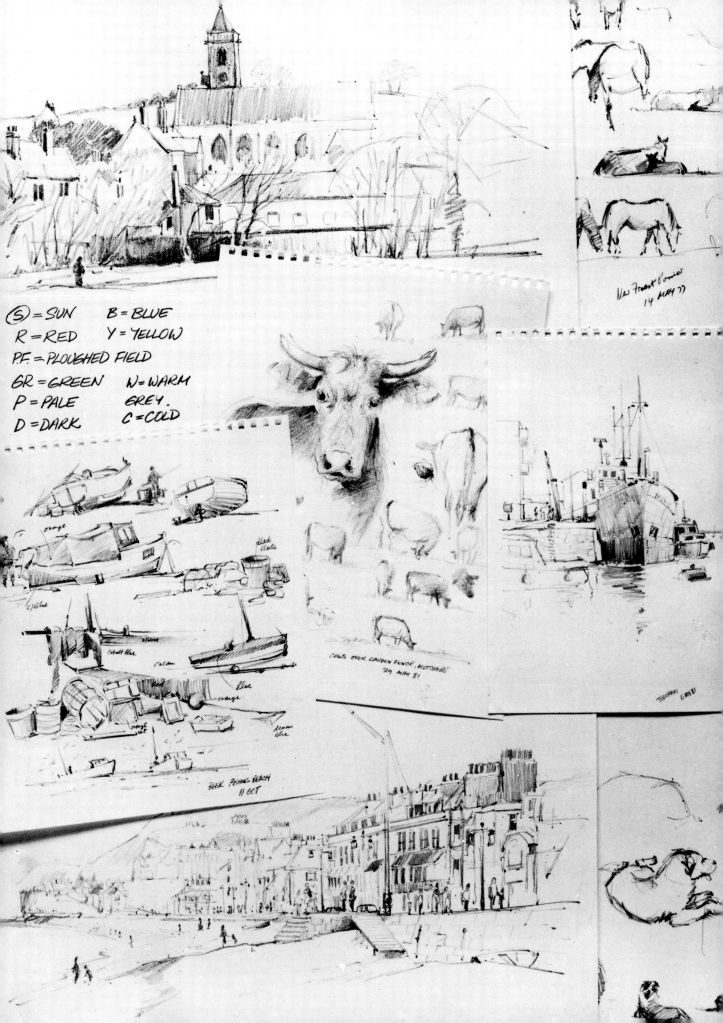

S = SUN B = BLUE
R = RED Y = YELLOW
P.F. = PLOUGHED FIELD
GR = GREEN W = WARM
P = PALE GREY.
D = DARK C = COLD

New Forest Ponies
14 MAY 77

COWS OVER CAMDEN FENCE MOTCOMBE
29 MAY 81

BEER FISHING BEACH
11 OCT

beauty of things around you, whether you are in an industrial town, a village, on a beach or in the countryside. Your subconscious too will retain information on what you see.

Remember that everything we see is stored away in our visual memory banks forever. We only need a trigger to bring a picture flooding back in seconds. If someone asks you if you were fortunate enough to watch man's first landing on the moon, that would be the trigger to your memory and within a second you could recall those pictures in your mind's eye. If you are an artist and have created a sketch of a scene, the *sketch* will always be your trigger or reminder of the scene.

The sketch is also an everlasting visible reference to keep for memory lane, or to use as information at a later date. An enjoyment sketch contains information even if it is only to show how good your technique was – or how bad. In such cases it can be used to improve it next time, or simply to serve as a reminder of how much you enjoyed the day out, therefore it doesn't matter how poor the technique was. If you have been out sketching before and had some marvellous times ask yourself if you would have had them, or even gone out on those occasions if you hadn't had sketching as an excuse. I have met many people for whom sketching is a reason to venture outside and enjoy their surroundings.

To me the sketch on page 8, **fig. 4**, is a typical enjoyment sketch. A few years ago I was in bed suffering from a slipped disc. It had never happened to me before and I was furious. On the second day of lying in bed, I couldn't settle to do any work due to the pain but I felt like drawing for the sheer delight of it. So with the aid of a mirror, June, my wife, had propped up on the bed for me, I sketched myself. I was not aware of the scowl on my face as I drew it, but when I look at the sketch now, it makes me realise what June had to put up with for nearly two weeks! If you

have a pencil and sketchbook with you all the time you can enjoy yourself anywhere, even with such simple equipment. Look at me in **fig. 6** with 10 minutes to spare in a car park.

Now the *information sketch* speaks for itself. It is a way of sketching aimed at gathering information, to be used later in the studio, usually to work a larger picture from. Naturally you will have your own ideas on what information you need from a sketch so I leave you to decide. However, it is no good going home and leaving your subject without enough information, because you may never see it again.

Here are some of the points to remember to put on your sketch: the position of the sun, the position of shadows, the sizes and positions of important areas, such as a boat, building, tree, lamp-post, person, etc., and their position in relation to each other. This is very important and I have written a section on how to 'measure from life' and transfer it to paper, on page 38.

Make sure you put something in your sketch to give an idea of scale. On page 8, **fig. 3**, in the drawing of two elm trees, the scale was shown by the sheep and figure. The information I was after was of the trees not sheep or the figure, or I would have drawn them larger and, of course, in greater detail. Incidentally, on the facing page of my sketchbook I had made a note that the first area of foliage from the bottom of the trunk was half as tall again. It was an important observation – a pity I didn't notice it before I completed the drawing!

If you are working in black and white prior to working in colour, then you will need to make colour notes. You can make yourself a code, for instance, D.G. = dark green, P.F. = ploughed field, L.R. = light red, and so on. This is very important. A week later when you look at your sketch, it is easy to forget whether a roof was red or blue slate. I

Fig. 5 *Chichester Cathedral, Sussex*, 29 × 42cm (11½ × 16½in)

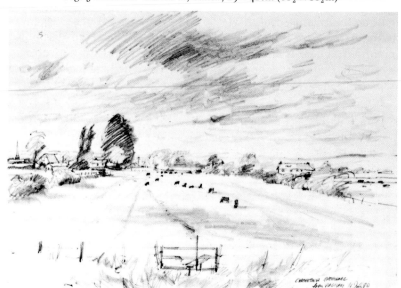

have worked from a sketch 10 years old, and although it helps me recall the scene, I can remember the day I sketched it, and the type of sky and atmosphere come flooding back, but details of colours of, say, an old cottage, a church or a boat are the pieces of information that are hard to remember even when looking at a sketch. But a colour code can tell you immediately.

However, when you do a watercolour sketch don't put any comments or coding on it. A watercolour sketch, because of the relaxed manner in which it is approached, (after all it's a sketch and not a finished picture) can often turn out to be a perfect watercolour painting, fit to grace any gallery or home. If you need notes put them lightly on the back in pencil. On page 9 I have put together sketches from some of my sketchbooks but I have also added a code of important items for those of you who have not used one before. Use this code and it will soon become second nature. Add your own, but keep the list short, otherwise your sketch will be hidden in letters.

The atmosphere sketch also speaks for itself. The important element to capture is the feel of the subject in its environment. If you were sketching a town scene, the type of day, whether warm, windy, rainy, cold and so on, is not the only component of atmosphere. You would have to capture such things as the mood of the streets, whether busy or quiet, crowded pavements, wind-blown leaves, tree-lined pavements, etc. The atmosphere provides 'the feel of the place'. I suppose you could say that it is an information sketch gathering atmosphere information. But in general the detail is not there, that is left to the imagination or to another sketch.

Before we discuss the specific sketch, let us think about actually leaving home and going out sketching. The most important item is *you*. You must have enough clothing to be warm. You can't relax and work outside if you are cold. You wouldn't watch television in the winter without some form of heating. To watch television and enjoy it, you need to be comfortable and warm. And the same applies to sketching. You can always take clothing off to cool down but you can't put more on if you haven't got it with you. Being comfortable is very important. There is enough to worry about drawing your sketch, without trying to balance on a wobbly fence, or getting your wellington boot sinking deeper into the mud and constantly having to change your balance onto the other foot. Naturally, some sketches can only be done in difficult positions, and there is nearly always someone who will try to do them, but I suggest you find somewhere else and make yourself comfortable.

I have covered what equipment you should use fairly comprehensively, starting on page 18, so I shall now tackle the problem of what to draw when you get outside. If you are like me and you know you are going out sketching beforehand, you will have a preconceived idea of what you want to draw. When you get to your starting-off point and you can't find what you had in mind you can become very

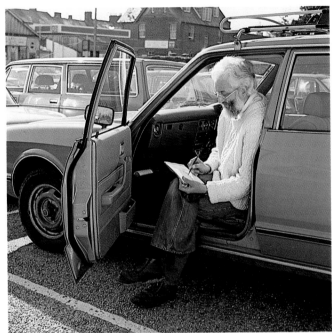

Fig. 6 Sketch at every opportunity. Look at me with 10 minutes to spare in a car park

frustrated. The only answer is to empty your mind completely of what you thought you might do and look around at what there is. Usually within minutes you see your surroundings totally differently, and can find a subject.

Then comes the most frequent obstacle and I still find it a problem to overcome. You see a spot and think: 'That's it!' But then you think it may be better round the corner, so you go to the next spot and think the same thing. And so it goes on until you run out of corners and views and an hour later you find your way back to the point you first started from, and decide that after all it's the best position. By that time you have probably lost an hour of daylight and you are weary and leg-worn before you even start. Believe me this is not exaggerated because I have done it and it takes a lot of self-discipline to stay at your first spot. The only answer I can give you to this universal problem is, when something makes you stop and take note and you say to yourself: 'I like that', then draw it. When you have sketched it, if you have time, *then* go round the next corner. If it is much better round the next corner, then blame me, but don't forget to thank me on all the occasions when you find that the first spot that inspired you turns out to be the best! Finally, when going out sketching, take the equipment you need, but take as little as possible. You can't travel very far loaded up like a human removal van!

I have left the specific sketch until last because in a way it embodies the other three: you must enjoy it, collect information, and atmosphere. The main difference is that the place and time are usually dictated to you and this means planning.

In painting the Brittany beach on page 12 the most

important element was the planning. Although I was on holiday with my family I knew that I would be doing a specific sketch for the book. We had a villa only 200 yards from the beach and after looking at the beach I decided that this was to be the scene for my sketch. I didn't attempt to do anything the first day because I wanted to get the feel of it and try to decide on the most inspiring view. I wasn't surprised that the first view that inspired me was the one I decided to paint. The only problem I had was the tide. Did I want it in or out? I decided it would be much more interesting to sketch when it was out and there would be interest from the rocks and people. For the first sketch (**fig. 9**) I used a 2B pencil on a cartridge paper sketchbook, 23 × 58cm (9 × 23in). I started on the right-hand page with the cliffs and rocks, and progressed over to the left-hand page.

It was very hot, but I wore a sun hat and somewhere among the pencil dots in the water my son, Clinton, and my wife, June, are swimming. I had no problems with this sketch everything went as planned including the group of people to the right playing *boules*. (It's a form of bowls, but the rougher the ground the better the players appear to like it, and they throw the ball rather than roll it.) They gave me enough time to sketch them in as a group and I decided to make them the main group on the beach.

The next day I planned to paint the same scene in watercolour to record the colour, and also to paint with the tide up in case I changed my mind when I got back home and wanted the finished painting with the tide in. It was very hot but a cool breeze was blowing off the land, so we settled down at the back of the beach out of the cool breeze. I had just got set up and organised with a board on my

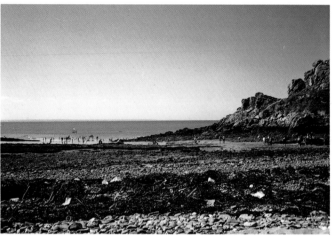

Fig. 7 The photograph I took of the Brittany beach so you can see what changes I made

knees (not an easel for this size sketch) and paper size 38 × 51cm (15 × 20in), when within minutes we were surrounded by people setting up camp on the beach within yards of us with sunshades, folding chairs, cane matting, bags and children (I love them but when they throw sand near my paintbox, I worry). It was to be expected – we had found the spot everyone wanted. Within minutes I couldn't see the water and low rocks, for brown sun-tanned bodies only feet away from my sketchbook! What a start!

There was only one thing to do. Naturally we weren't pleased to have to pack up again and walk in the heat to the middle of the beach. But, once we were settled everything was perfect. I used a sheet of Greens RWS 140 lb Not surface watercolour paper and drew in the picture with an HB pencil. The tide was coming in and I left the

Fig. 8 *Brittany Beach*, watercolour, Greens RWS 140 lb Not surface, 38 × 51cm (15 × 20in)

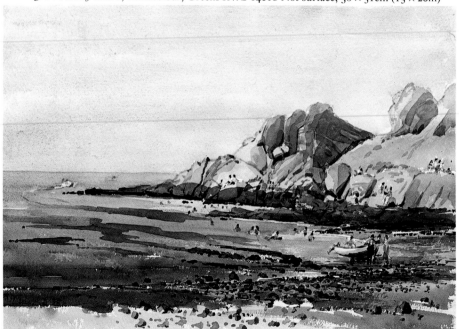

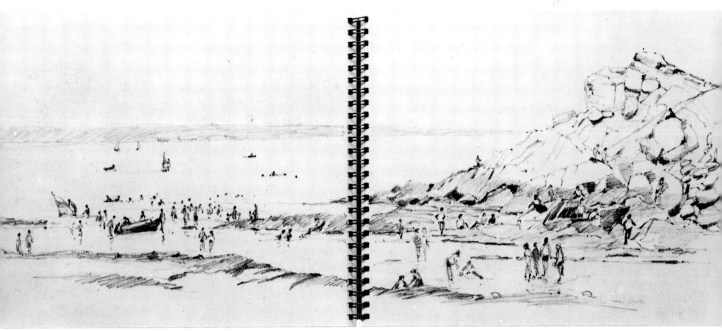

Fig. 9 My original pencil sketch for *Brittany Beach*, 23 × 58cm (9 × 23in)

water line until I was ready to paint in the sea. I started with the sky then worked down the rocks leaving the paper white where the people were to go in, then I painted in the sea which had come up further since I started to draw it. After that I put in the people, the boat and the beach.

The only thing that I was not prepared for, but you will be now, was children and dogs running past on the soft sand spraying the open paintbox as they went. After the first two mishaps I kept a polythene bag ready and when they came, (which included Clinton once) I pulled the bag over everything. I took a photograph of the beach (**fig. 7**)

to help you to see what changes if any I made to the sketches.

When we got back to England and I painted the finished painting (**fig. 10**) I used acrylic (Cryla colours) on canvas, 25 × 61cm (16 × 24in) and I felt as if I had known that beach all my life. It was a most enjoyable exercise. Some specific sketches can be more demanding, but if all goes well with good planning, they can be very rewarding. You must try a 'specific-sketching' day out, so why not try a beach when you are on holiday, or a local event? Remember: the event won't wait for you, so plan and be ready.

Fig. 10 *Brittany Beach*, the finished painting completed at home on canvas in acrylic (Cryla colours), 25 × 61cm (16 × 24in)

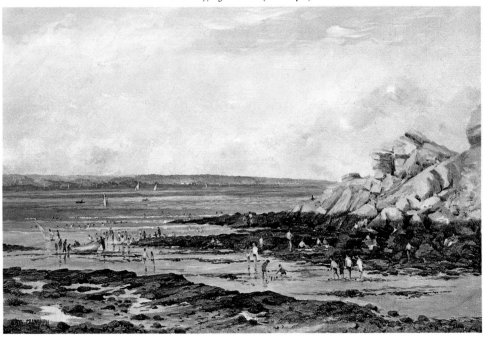

ELEMENTARY DRAWING AND PERSPECTIVE

You don't need to know all about perspective to be able to paint or sketch a picture. But I believe, if you know the basics of perspective, your sketching will become easier and the result more convincing. Most people are familiar with the terms horizon, eye level and vanishing point, so let us see how they relate to sketching.

When you look out to sea the horizon will always be at your eye level, whether you are on a cliff top or lying flat on the sand. So the horizon is the eye level (E.L.). If you are in a room naturally there is no horizon, but you still have an eye level. To find it hold a pencil horizontally in front of your eyes at arm's length and your eye level is where the pencil hits the opposite wall. If two parallel lines were marked out on the ground and extended to the horizon, they would come together at what is called the vanishing point (V.P.). This is why railway lines appear to get closer together and finally meet in the distance – they have met at the vanishing point.

To some people perspective comes naturally and to others it is hard work, but unless you are going to draw complicated buildings or large machinery and want a high degree of detail, don't let perspective worry you. You will find you use perspective (in the sense of drawing diagrams similar to those on the page opposite) very little when you are out sketching. I draw without using perspective guidelines unless my drawing looks wrong – and I can't get it right. Then I go back to the drawing board and check the perspective. If you know a few simple rules you can correct your sketches easily.

Let's go through a few basic rules so that you know enough about perspective for everyday sketching. When you look at the opposite page please *don't let it put you off!* Although I have just drawn it, looking at the finished diagram could put *me* off drawing! I drew it freehand on tracing paper with a Rotring pen, and a felt-tip pen for the thick lines. Now read this very carefully. At the top of the page I drew the eye level (E.L.). Then I drew a square (**fig. 11A**) and put a mark to the left at eye level, and used it as my vanishing point (V.P.). The object is to make the square in **fig. 11A** into a cube. Draw a line from the V.P. to both left-hand corners of the square (**fig. 11B**), and then do the same to the right-hand corners (**fig. 11C**). This gives us our two sides.

Draw a line between the top and bottom guidelines parallel to the left side of the square, see points (**a**) and (**b**), and this gives you one side of your box (**fig. 11D**). Then draw a horizontal line from point (**a**) to link with the guideline the other side of the box. Do the same again starting at (**b**) and draw a horizontal line to the lower guideline. Finally join up the points opposite (**a**) and (**b**) with a perpendicular line (**fig. 11D**). You now have your cube and have succeeded in representing a three-dimensional object (by giving it depth) on a two-dimensional surface (your paper) with basic perspective theory using eye level and vanishing point.

In **fig. 11E**, I have turned the cube into a house, by adding a roof. To find the centre of a square or cube, whatever its proportions, draw two diagonal lines from corner to corner (**fig. 11E**) and where they converge is the centre. From this point I drew a guideline up to meet another line drawn from the V.P. to the point of the roof. Where these two lines cross is the apex of the roof.

All this has been done looking at a cube side on (showing only one side). In **fig. 11F** the house on the corner has two vanishing points, one on the left and one on the right. The principle is the same as for the first cube you drew, except the lines on *both sides* of the cube meet at a vanishing point. I have put more buildings into this to show you how a street is built up – two streets in fact, one going to the left and one to the right. The house on the right with the chimney is seen side on, so the other sides aren't shown.

In **fig. 11G** I have drawn a 'bird's eye view' of the same scene and this has been done by changing the eye level and putting it higher. The position you would see, for instance, from a window or a bridge. **Fig. 11H** is just the opposite – the 'worm's eye view'. The eye level is very low, in fact, at ground level. Notice how *all parallel* lines meet at the V.P. and this includes windows, windowsills, doors, gutters, pavements, the line of lamp-posts – everything. In **fig. 11F** there is even a guideline for the top of the chimney.

My way of putting this into practice out sketching (especially if I am doing buildings and man-made objects) is to find my eye level (i.e. I hold my pencil horizontally at arm's length in front of my eyes and where it reaches the objects in the scene is my eye level). I then draw it in on my sketch pad, position my centre of interest and work from there.

When you do this, hold your pencil at arm's length and let it run down the length of a building or buildings. Take the line of the eaves, say the first house in **fig. 11F**, and see roughly where it meets your E.L. Then draw that line on to your paper. Still using **fig. 11F**, again hold your pencil at arm's length, level with the bottom line of the houses, and where it meets the line of eaves is your vanishing point. Then you have a start and you work everything from that. Please read all this very carefully and practise. Try putting your eye level high and low and use one or two V.Ps. As you practise you will 'see' perspective when you are sketching and this page of complicated-looking lines opposite will be a problem of the past. Good luck!

Fig. 11

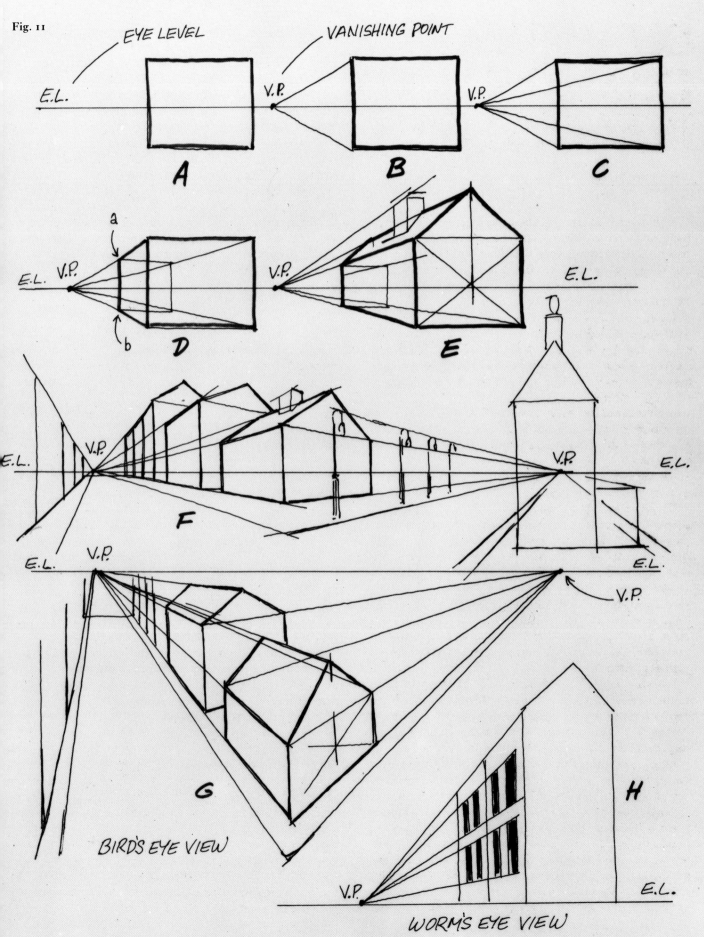

EYE LEVEL

VANISHING POINT

E.L.

V.P.

V.P.

A

B

C

a

E.L.

V.P.

V.P.

E.L.

b

D

E

E.L.

V.P.

V.P.

E.L.

F

V.P.

E.L.

E.L.

E.L.

V.P.

G

H

V.P.

E.L.

BIRD'S EYE VIEW

WORM'S EYE VIEW

15

DESIGN AND COMPOSITION

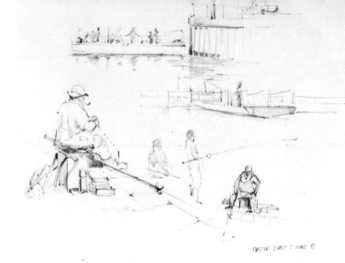

Design is so much a matter of personal observation, that it is difficult to say what is good or bad. We don't always know when we like a picture, how much the design and composition influence us. It may be the subject or the colours that attract us. Design is a specialised subject and needs a lot of study. As far as we are concerned with sketching, take it from simple beginnings and let your instinct guide you with the help of some basic rules. I have entitled this section *Design and Composition* because to me, in painting, they mean the same thing, namely: *the positioning of objects on paper, in a 'happy' way that enables you to tell a story visually to the onlooker.*

Let us start with a very old system I was taught at art school, which is now second nature to me. Although it is a good rule of thumb to work to, don't be stereotyped by sticking rigidly to rules. We are all individuals and a deviation from the expected to a more personal choice can make an original and sometimes unusual picture. In **fig. 16**, page 17, I have divided the paper into thirds, vertically and horizontally. Where they cross at points **A**, **B**, **C** and **D**, I have called the focal points. If your centre of interest is positioned on or around a focal point, then you should have a good design. Look at the people standing on the cliff at focal point **A** (**fig. 18**), the sketch looks 'happy'. (By that I mean it works well.) Now look at the sketch below it, where the two figures are on the cliff, but in the centre of the picture. It looks uninteresting and characterless. The little sketches in **fig. 20** show simple designs using different focal points. The centre of interest can always be made to stand out by being different to its immediate surroundings, i.e. by using contrast when working in black and white, or vivid or different colours when working on a painting.

When you are sketching a landscape or seascape, always have the horizon above or below the centre of the paper, never in the middle. Start by putting in your centre of interest at your chosen focal point, then work away from it. You will find that nature's lines, if observed carefully – hedgerows, rivers, roads and so on – will help to bring the picture together and form a natural design. To start with put in everything you see, later experience will tell you what, if anything, to leave out. Don't be tempted to distort a view to get more on to your sketchbook, as the design and the objects in relation to each other will look wrong.

Look at **fig. 12**. When I sketched that I did not intend to make a picture, they were just information sketches, all together on a page of my pad: the fisherman, the river,

Fig. 12 Information sketch, 23 × 29cm (9 × 11½in)

Fig. 13 Information sketch, 21 × 29cm (8½ × 11½in)

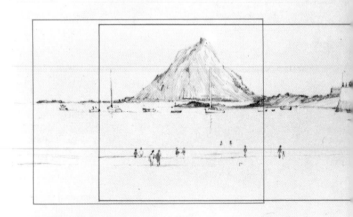

Fig. 14 This sketch of Val André shows the advantage of drawing plenty of information onto your sketch. Although it is simple, you can see two very interesting ways of using it. The blue outline gives the shape for one picture, with the island as the centre of interest (positioned at focal point A). The red outline gives a different view, with the two figures in the left foreground as my centre of interest (positioned at focal point B). If I were to paint from this I would use strong local colour to emphasize the figures on the beach as the island could be overpowering (or you can make the island stay in the background by painting it in paler colours). 23 × 29cm (9 × 11½in)

Fig. 15

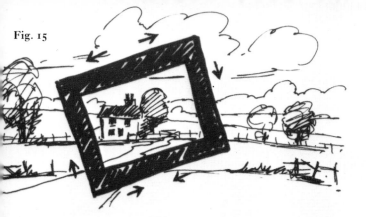

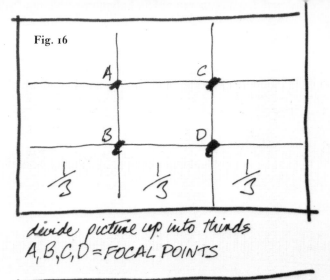

Fig. 16

divide picture up into thirds
A, B, C, D = FOCAL POINTS

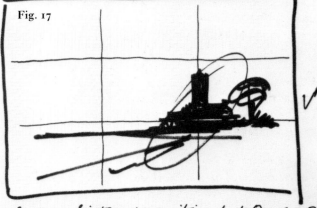

Fig. 17

Centre of interest positioned at Ⓓ – GOOD

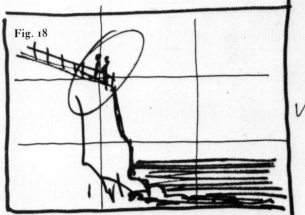

Fig. 18

Centre of interest positioned at Ⓐ – GOOD
Below – Centre of interest in centre of picture
this is wrong.

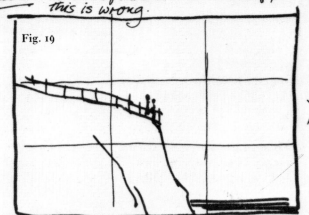

Fig. 19

ferry and so on. Looking at **fig. 13**, there was no way that I wanted to sketch the chickens in a design on my sketch pad. It's difficult enough to sketch them anyway, some part of their anatomy seems to move every hundredth of a second. *So there are sketches that do not need to be designed on your pad.*

Your object should be to get as much information as possible. This is what I have done in **fig. 14**. I started the island in the middle of my sketchbook and worked on either side of it. This gave me enough room to put on the information I needed to be able to work from it at home. There I can design and redesign to my heart's content. Look at **fig. 14** again and you will see I have shown two different ways of using the sketch as a painting. If the information you want when you go out relates to design, then naturally your information sketch should be drawn with design in mind.

If your subject is large such as a landscape or a village square and you can't decide which part to sketch, then cut a mask out of thin card with an opening of about 15 × 10cm (6 × 4in). It is a good idea to have one cut in proportion to each of your sketchbooks then the view you see through it will fit your sketchbook exactly. (See page 44 for working out proportions.) Hold up your masking card at arm's length and look, with one eye closed, through the mask 'window'. Move it around slowly up and down, and backwards and forwards until you see a 'picture' that fires your imagination (see **fig. 15**). Make mental notes of where your arm is and where the key points of the scene hit the inside edge of the mask. Mark these on your sketch pad and away you go!

This all may sound very complicated to a beginner, but believe me, design will come naturally as you progress and develop your own style, and the more you sketch the sooner your design will become second nature.

Fig. 20

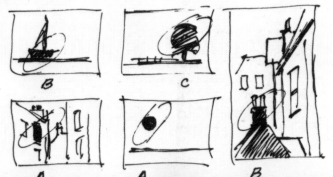

WHAT EQUIPMENT DO YOU NEED?

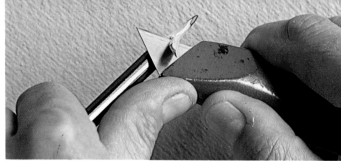

Fig. 21

Sketching equipment can be far less comprehensive than that needed for painting. Some people – and I tend to be one of them – collect a wide variety of different materials, which is all part of being an artist. I have an oil painting palette that I have had since I was at art school and enough brushes to paint the hull of the QE2. I never seem able to throw away my old equipment, I always think I will find a use for it later – usually I don't! Whatever equipment you buy, I suggest you buy the very best you can afford – it makes working easier and you produce better results.

Sketching materials for black and white
In **figs. 26** and **27** you will see the different mediums you can use for black and white sketching. (The term black and white usually refers to black as the drawing or painting medium and white is the paper it is worked on.) All the materials are listed on this page. On the following pages, I have taken one or two mediums at a time and explained the way to work with them.

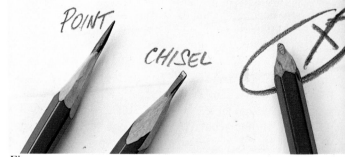

Fig. 22

The most important piece of equipment is *the pencil*. We all tend to take the pencil for granted and it is not surprising – we all have one – somewhere, and most of us have used one since childhood. Now let us take a closer look at the pencil. A good artist's drawing pencil has 13 different degrees of lead. The middle one, the most common for everyday use, is HB. On the B side the leads become softer and darker as they reach the top of the scale, i.e. B, 2B, 3B, 4B, 5B and 6B (the softest); and on the H side the leads become harder and lighter, i.e. H, 2H, 3H, 4H, 5H and 6H (the hardest). For general sketching purposes all you need is an HB and 2B. But try out different pencils to see which suit you.

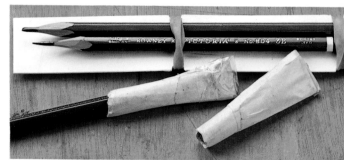

Fig. 23

In **fig. 25** you will see the different tones you can produce using HB, 2B and 6B pencils. When you sharpen your pencil (**fig. 21**), use a sharp knife and cut off controlled positive 'slices', making a long gradual taper to the lead (so you can see the point easily when you are sketching). **Fig. 22** shows the first pencil sharpened to a good point and the second pencil sharpened to a flat chisel-shape end. This is good for shading and making broad strokes. The third pencil is sharpened badly and difficult to draw with. I borrowed this from one of my new students!

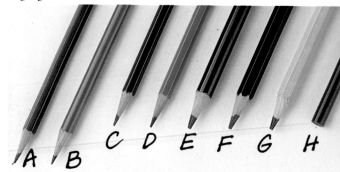

Fig. 24

There are two ways of protecting your pencil points when you take them out (see **fig. 23**). The first is to put them on a piece of thick card or the flat plastic sheet out of a brush holder and hold them on with rubber bands; and the other way is to make a cover for the lead out of paper.

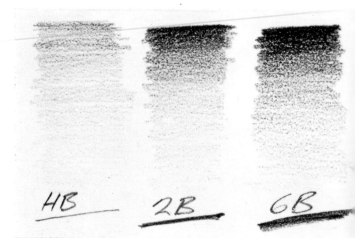

Fig. 25

In the illustration I rolled some cartridge paper around the pencil and wound masking tape around it.

Fig. 24 shows a selection of first class Rowney pencils. I use the No. 804 Victoria (pencil *A*). It is a first class artists' pencil but the choice is as personal as choosing a series of paint brushes. The second, *B*, is series No. 820 for technical drawing and general use, when a really strong pencil is needed. Pencil *C* is the same as *B* except it is made in HB only and is hexagonal instead of round (some people prefer this for holding). *D* is series No. 810 Commander and is a good quality general purpose pencil. *E* is series No. 876 Round Black Beauty and is an extra thick black pencil (equal to 4B). *F*, No. 874 Black Beauty is the same but hexagonal. *G*, No. 874A Black Beauty is similar to *F* but has four colour finishes (good for easy recognition). Finally *G*, No. 1020 is a charcoal pencil. In figs. 26 and 27 are materials you can choose for black and white sketching. If you are just starting don't feel you have to buy everything. You can start – and continue – with only one pencil or pen, and become the best pencil or pen and ink artist in the world!

The materials in fig. 26, for our purposes come under the overall heading of pencils. There are various pencils, charcoal sticks, charcoal pencils, conté pencils, conté crayons, a box of pastels with a tonal selection ranging from black through to white, sketchbook, drawing papers, kneadable putty rubber and fixative. Fig. 27 shows materials for sketching in ink: a bottle of black Indian ink, fountain pen ink, pen holder, nibs, palette for diluting ink with water, sable brush, fountain pen, ballpoint pen, Rotring pen, felt-tip pens, sketchbooks and blotting paper.

The size of sketchbook you choose is up to you. I have different sizes for different purposes. If I am going out on a sketching trip or to do a complicated information sketch I take the largest sketchbook I work with, an A3, 30 × 42cm (11¾ × 16½in). I have a smaller one for general use as it's easier to carry and I keep an A5, 14 × 21cm (5¾ × 8½in) in my car-door pocket, just in case I am in a lay-by or held up in traffic. If there is anything around to inspire me, the sketch pad is always there. Don't forget your pencil!

If your pad is too small to rest your hand on, always try to find something to rest the pad on. I have seen students standing up holding a *small* pad in one hand and drawing with the other, but with nothing to rest their drawing hand on. It is very difficult to draw standing up, but even more so if you can't rest your hand on the drawing surface.

Sketching materials for colour work
The same principles apply to working in colour as black and white – you can have as many or as few materials as you want.

Pastel colour There are over 50 different pastel colours, and each one is available in several tints, making nearly 200 pastels in all. Rowney pastels are graded from Tint 0 for the palest to Tint 8 for the darkest. The best way to start is to buy a box of 12 or 36 Artists' Soft Pastels for Landscape. I have used the pastels in these two boxes for all the exercises. When you get used to the medium you can buy different tints, colours or refill pastels individually.

Fig. 29 shows the basic sketching set for pastel work. Start with either of the two boxes I mentioned above. The

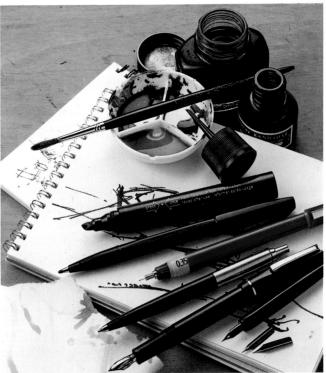

| Fig. 26 | **Pencil sketching set** | Fig. 27 | **Ink sketching set** |

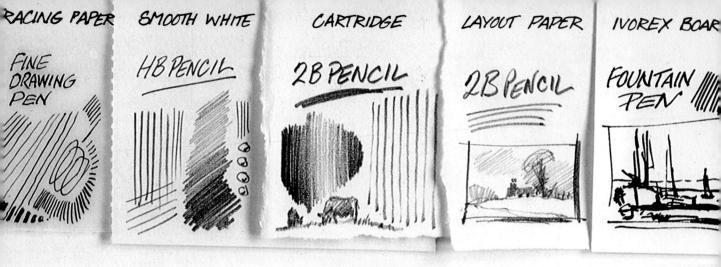

Fig. 28 I have illustrated specific papers suitable for black and white, and colour work; and I have named the type of paper and drawing medium used

one illustrated contains 12 colours for landscape painting. You will need some paper or a pastel sketch pad with a selection of coloured sheets, plus some fixative, a bristle brush (for rubbing out areas of pastel) a kneadable putty rubber, an HB or 2B pencil and a rag (for cleaning your hands).

Watercolour You can buy watercolours in tubes, or in half or whole pans. I do not advise beginners to use tubes because it is difficult to control the amount of paint you get on the brush. You can buy pans individually or in boxed selections. The colours I have used are: Payne's Grey, Burnt Umber, Hooker's Green No. 1, French Ultramarine, Crimson Alizarin, Yellow Ochre, Coeruleum Blue, Burnt Sienna, Cadmium Red, Raw Umber, Raw Sienna, Cadmium Yellow Pale.

Fig. 30 shows the basic sketching set for watercolour work. You can start with two brushes: a size No. 10 and a size No. 6 round. The quality you get will depend on the price you pay, but they should be sable. You need a paintbox to hold 12 whole pans of colour or 12 half pans (the one illustrated holds whole pans), or a small Rowney sketching box with its own water container attached (illustrated), which is ideal for putting in your pocket or your handbag, (for more experienced artists I have also shown tubes of paint as another alternative but, HB and 2B pencils, a kneadable putty rubber (this type of rubber will not smudge), a drawing board with watercolour paper or a watercolour sketch pad, blotting paper, a sponge and a water jar. I also suggest you carry a tube of white paint with your equipment. I use Designers' Gouache.

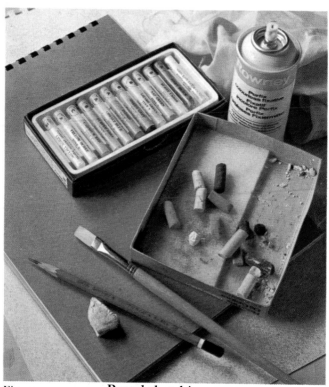

Fig. 29 **Pastel sketching set**

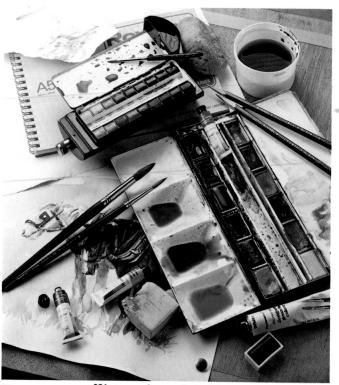

Fig. 30 **Watercolour sketching set**

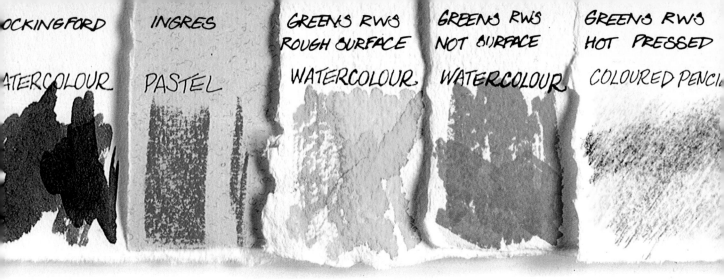

OCKINGFORD INGRES GREENS RWS ROUGH SURFACE GREENS RWS NOT SURFACE GREENS RWS HOT PRESSED

ATERCOLOUR PASTEL WATERCOLOUR WATERCOLOUR COLOURED PENCIL

Brushes

In painting the most important tool that an artist uses is his brush. Like the pencil in a pencil sketch, a brush is used to communicate what you see and will determine how successful you are in conveying it. Therefore, make sure you are happy with the ones you choose. In the sketching set, I have suggested a size No. 10 round and a size No. 6 round. (The series numbers refer to the Rowney catalogue and will help you identify the different types of brush.) Each series varies in price, but a Rowney Series 34 is a good hard working round sable brush in the middle price range. Another brush I recommend is a Rowney Series 56 size No. 2. This is ideal for thin line work. In **fig. 31** there is a selection of brushes to show you the different sizes available. They are all reproduced actual size. All the brushes from size No. 00 to No. 12 are round sable brushes. Some brush series have additional sizes such as Nos. 9, 11 and 14. Series 270 is a nylon brush and can be used in place of sable if you prefer (they are less expensive). The last brush is a Series 63 squirrel hair wash brush, a large flat brush for putting on large watercolour washes.

Paper

The subject of paper is so broad I cannot give a complete explanation in the limited space available here. To give you an idea of the basic differences, I have illustrated

specific papers in **fig. 28** suitable for black and white, and colour work. These are reproduced actual size and I have named the paper and the drawing medium used to help you know what results you can get from different papers.

For pencil work a smooth paper is used normally: cartridge paper which has a slight grain (tooth), is an all-purpose sketching surface. You can buy all sizes of sketch pads with this paper. A smoother surface can be used with a paper called 'smooth white' in Rowney sketchbook Series A42. Another Rowney sketchbook with an even smoother surface containing sheets of Ivorex double-sided board is ideal for pen, Rotring, pencil, conté and watercolour washes.

All these papers can be used for colour sketching, but the best watercolour paper, is hand made and comes in three distinct surfaces, i.e. Rough, Not, and Hot Pressed. The Rough surface paper speaks for itself. The Not surface has a good grain on it (I usually use this one), and the last one Hot Pressed (HP) has a smooth surface. Good watercolour papers are also available in pad form. If you can't get your favourite paper in a pad, buy the paper and cut it to the size you want. Then put some sheets on a piece of hardboard and hold them on with clips or rubber bands. Ingres paper is ideal for pastel work and can be bought in various coloured tints in a sketchbook.

Fig. 31

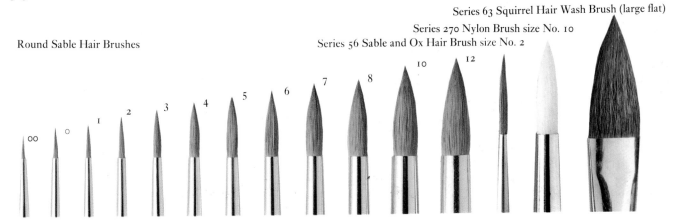

Series 63 Squirrel Hair Wash Brush (large flat)

Series 270 Nylon Brush size No. 10

Series 56 Sable and Ox Hair Brush size No. 2

Round Sable Hair Brushes

WORKING IN BLACK AND WHITE
PENCIL

Now we can sort out the different mediums available and you will see that your materials can be very simple to carry and don't constitute a tremendous expense. In these photographs I show you how to hold and use your chosen medium. You will see two types of arrow, which are important. The solid black arrow shows the *direction of the pencil strokes*, and the outline arrow shows the *direction in which the pencil is travelling over the paper*. I use these arrows throughout the book. All you need for your basic pencil sketching set are one pencil, a rubber and a sketch pad (**fig. 32**). This, for me, is the most versatile and pleasing way of sketching. It is also one of the least expensive. At least 60 per cent of my sketching out of doors is done with a pencil.

Remember, most of us have used one since childhood, so we should have some idea of how to use it! Unfortunately, old habits die hard and all these years we have been holding a pencil for writing. This way of holding it is fine for controlled drawing and careful line work (see the 'short' drawing position shown in **fig. 33**), but for a more free and flowing movement, especially needed in working the sketch over a large area, you must hold your pencil at least three inches from the point and have the pencil at a flatter angle to the paper than that in **fig. 33**. This 'long' drawing position will give much more versatility to the pencil strokes (**fig. 34**). **Fig. 35** shows the 'flat' drawing position which is a totally different way of holding your pencil. The pencil is almost flat on the paper, held off by your thumb and first finger, which allows you to touch and move over the surface. This way of working your pencil allows you to work in fast broad strokes, using the long edge of the lead to give large shaded areas.

With these three different positions I have described, there are infinite variations. Using these as a base, learn to work with a pencil, all over again. Practise whenever you can, doodle, do anything. Don't worry about drawing, just get used to the pencil and what *you* can make it create on paper. On the opposite page the pencil sketches are from my sketchbooks and have been put together to form a page of this book. They appear two and a half times smaller here than their actual size. They are not contrived in any way for the book, they represent the way I work. Naturally, I like to think that my later ones are better than some of my earlier ones!

At the bottom of the right-hand side of the page opposite I have doodled to show what the pencil can do. When you practise try using three tones with white paper.

Fig. 32 **Pencil sketching set**

Fig. 33 'Short' drawing position

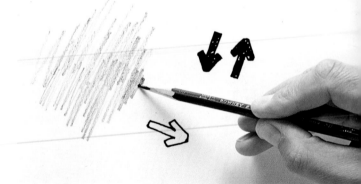

Fig. 34 'Long' drawing position
Fig. 35 'Flat' drawing position

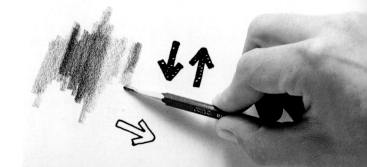

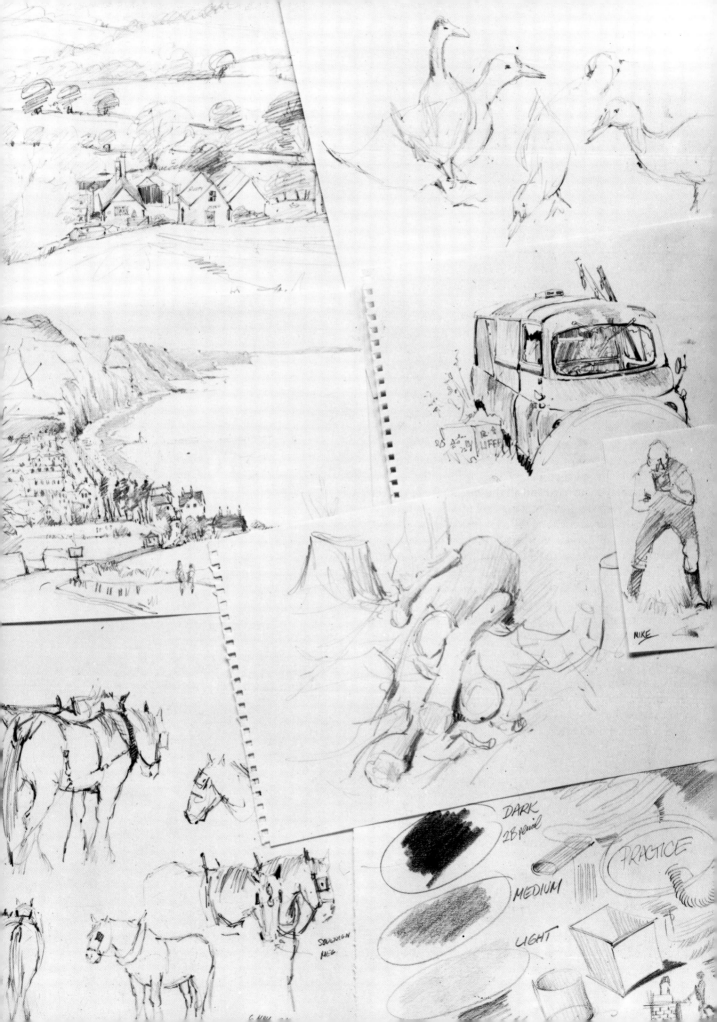

MIKE

DARK
2B pencil

MEDIUM

LIGHT

PRACTICE

SOVEREIGN
MEG

WORKING IN BLACK AND WHITE
INK – PEN AND WASH

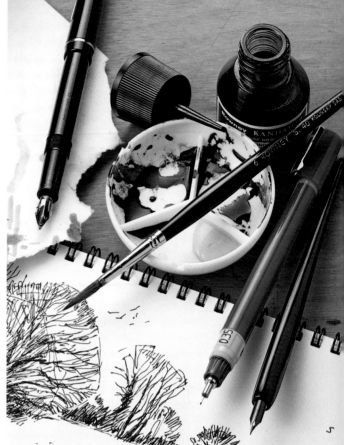

Fig. 36 Ink sketching set

Pen and ink, and pen and wash are two very old and traditional ways of drawing and sketching. Pen and ink simply means using a pen as the drawing instrument. Pen and wash involves using a pen for drawing and a brush for putting on the ink, either undiluted, or diluted with water to enable different tonal values to be applied in wash form over the line pen work. This latter version gives more tonal value to a sketch very quickly. If you use black Indian drawing ink, never put a brush with water into the ink, always use a separate palette (a small round plastic one for instance) put a brush full of ink into it and then use your water to thin the ink on the palette. It is really like water-colour painting but using only one colour.

The mapping pen has a nib that gives the finest point and is used universally for fine pen drawing. You can buy various types of drawing nibs and these are all 'dip-in-ink' pens. This means for sketching you must take with you a bottle of ink, water, and a palette and brush if you intend to work over with wash. You must use waterproof drawing ink if you are applying wash, or the line work you have already done will run when you put watery ink over it. Experiment with different nibs to start with and get the feel of working with them. Don't be afraid of them, they are more flexible and stronger than you imagine, but if you press hard on an upstroke you could damage the nib. You need a hard surface paper or board for fine nib work and the Rowney Drawing Book containing Ivorex board, illustrated on page 20, **fig. 28**, is perfect.

Fountain pens have a less 'scratchy' feel and flow over the board or paper more readily than 'dip-in' pens, and they also have the advantage of not having to be dipped in ink every few minutes. They can work very well on cartridge paper. Many artists prefer fountain pens for sketching as they are so portable.

You can buy a type of fountain pen called Rotring. It is filled with special ink and the nib is a very fine tube, which has a needle valve that controls the flow of ink through the nib. Different grades of nib are available. The only disadvantage is that the pen has to be held upright for it to work properly, but it's worth practising to get used to it. **Fig. 36** shows an ink sketching set, but of course it has variations: 'dip-in-ink' pen, ink and sketchbook; 'dip-in-ink' pen, ink, brush, palette, and water (also take blotting paper and sketchbook); fountain pen and sketchbook; Rotring and sketchbook. The choice is yours. My sketches are on the opposite page again. Don't forget to doodle and practise.

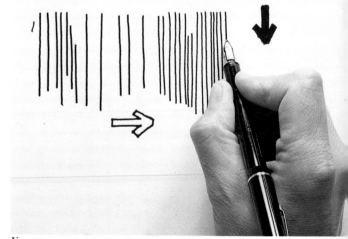

Fig. 37
Fig. 38

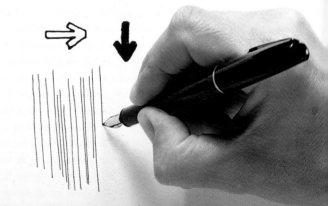

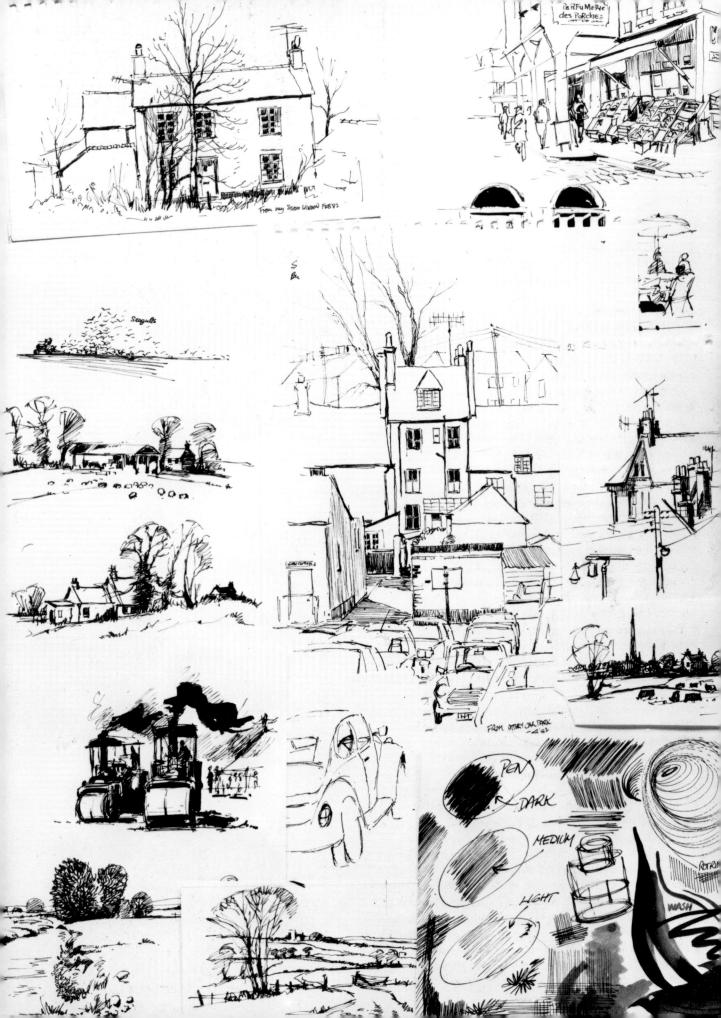

From my Studio Window Feb '82

Parfumerie des Porches

Seagulls

S Bu

From Ottery Car Park

PEN

DARK

MEDIUM

LIGHT

ROTRING

WASH

WORKING IN BLACK AND WHITE
CHARCOAL, CONTE PENCIL AND PASTEL

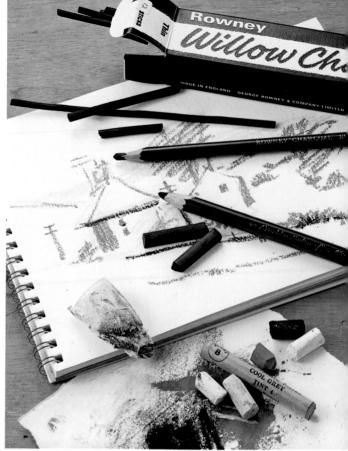

Fig. 39 **Charcoal, conté pencil and pastel sketching set**

Charcoal is not the medium for the fussy, neat and careful worker. It is for broad adventurous sketching, where one stroke of the charcoal can cover inches of paper to get an effect. It is exciting to use especially for atmosphere sketches of landscape; skies can be put quickly on paper (if observed correctly first), and large masses of landscape can be worked covering your paper rapidly with large tonal areas. Charcoal can smudge so you will have to practise working with your hand *not* resting on your paper.

This is very difficult to get used to, but like all things it is worth trying to get the results you want. You will find that by sketching without resting your hand, your work will become more free and spontaneous, and you will find that detail is kept to a minimum. For some of us this can be one way of getting out of the habit of being too fussy and detail-minded when it isn't required.

Charcoal can be worked on almost any paper, but I suggest you start on cartridge paper. Naturally, work on other surfaces too until you find one that suits you. Charcoal is not the easiest medium to work with. It doesn't suit everybody, but you should try it. Charcoal can be bought in different grades, in stick or pencil form. You have more freedom using a stick, because you can use the long edge for broad shading, but a pencil is cleaner and easier to use. It's up to you. Always fix your work with a spray fixative. This will stop it smudging and preserve it for years.

The sketching set in **fig. 39** also offers a choice. You can take a charcoal pencil, sketchbook and putty rubber (note: it is not always easy to rub out charcoal), or sticks of charcoal instead of the pencil, or both. Even so it is a small and easy sketching set to carry. If you have room, take an aerosol can of fixative with you to spray your sketch as soon as it is finished.

Conté pencils also come in sticks and are similar to charcoal but harder, and they can smudge too so be careful. You can also buy them in white and red. Experiment using white with the black – try a grey paper to work on. Your sketching set is simple, pencil or sticks and sketchbook, but as with charcoal, conté cannot always be rubbed out.

Finally, there is a tonal set of artists' soft pastels on the market ranging from black through five tones to white. Your sketching set is the same as for the coloured pastels, except you don't need coloured paper (page 20 **fig. 29**).

You can have a lot of fun using these smudgy materials. If you haven't used them before try them, new worlds may open up to you. But remember – practise.

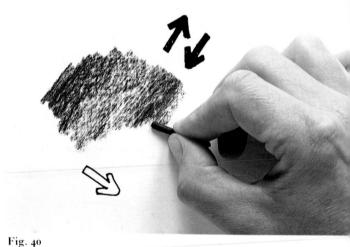

Fig. 40
Fig. 41

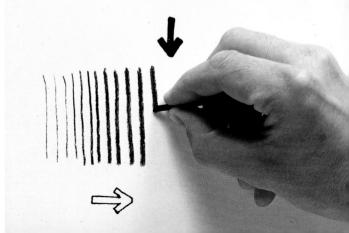

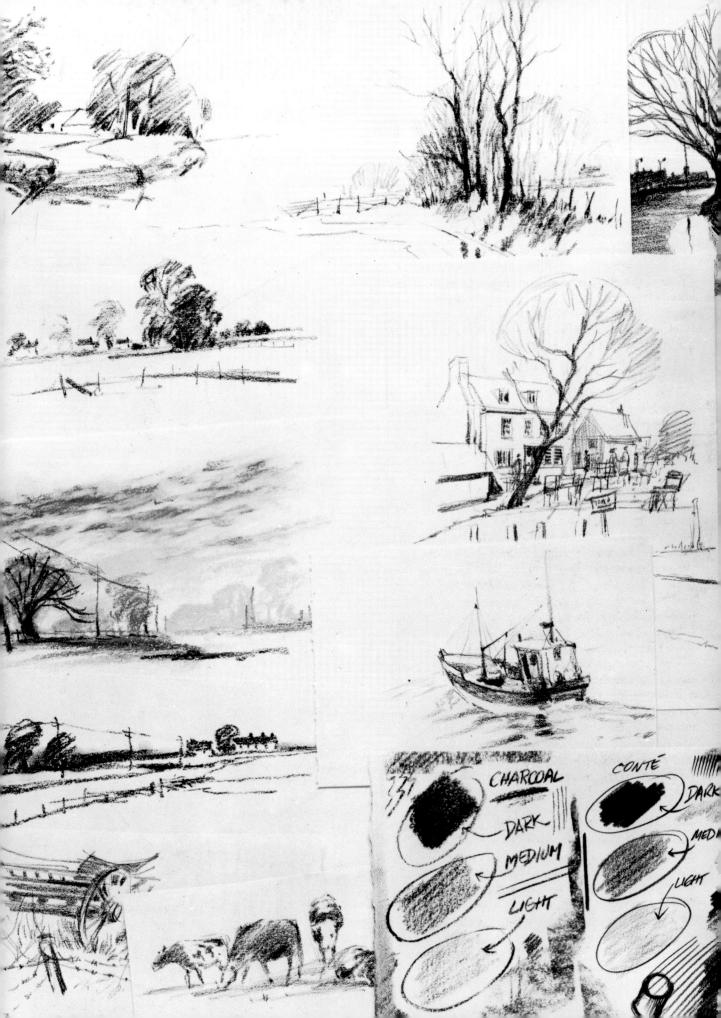

CHARCOAL

DARK

MEDIUM

LIGHT

CONTÉ

DARK

MEDIUM

LIGHT

WORKING IN BLACK AND WHITE
FELT-TIP AND BALLPOINT PENS

Fig. 42 Felt-tip and ballpoint pens sketching set

One thing is certain, the old masters didn't use these materials. I wonder what they would have said about them? We shall never know, but they are very good drawing aids for the artist and can be used very well for sketching. The one disadvantage of the ballpoint is that a sketch looks a little mechanical. This is because there is not much variation in the line that is drawn, especially if we compare it with a pencil line. But, look at its advantages. It is inexpensive. You don't have to dip it in ink or fill it. You can get black. You can get different grades of line (when you buy the pen). If you are miles from anywhere the chances of it not working are remote, and finally even if you are not out sketching you probably would have one in your pocket anyway. These are the advantages, so if you accept its performance, it is a very good sketching tool. You can work with it on almost any surface. I like to think of it as a good emergency tool, but not number one.

Felt-tip pens have more character in their lines than the ballpoint and you can get them in all sizes of nib from very fine to very broad. I have seen some up to 6cm (2in) broad but these sizes are for specialist uses only, and are no good for our sketching trips! Art supply shops do sell them normally up to approximately 6mm ($\frac{1}{4}$in) wide. These can be used for thin lines as well as thick, because the nib is usually broad and flat (chisel-shaped), see **figs. 42** and **43**. A sketching set for this type of work would consist of a ballpoint or felt-tip pen and a sketchbook, see **fig. 42**.

The normal thin felt pen is used in the same way that a pencil is used and can get good sketching results. I think it should be part of your sketching equipment to be used when the subject or your mood calls for it. Generally you can work with it on any paper that you would with pencil. Remember, there is no rubbing out with a ballpoint or felt pen. This is a good exercise to make you observe the subject well, before drawing any lines on paper. If you draw some lines that are wrong don't start again, it will give your sketch depth and a feeling of life if you work over them – unless of course every other line is wrong! My examples are on the opposite page and my doodles are on the bottom right-hand side. Use scrap paper to learn about your drawing tool. Scribble, scratch and scrawl on paper after paper, until you know what *you* can get from your chosen drawing instrument.

Now I have described nine different tools for drawing in black and white. Among them is one that suits you, more than another. Try them until you find your favourite. Enjoy experimenting and good luck!

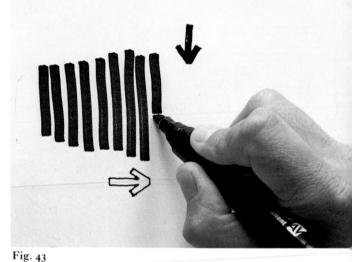

Fig. 43

Fig. 44

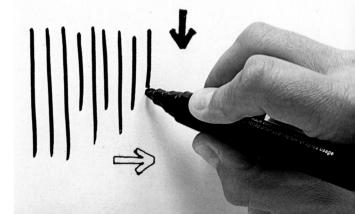

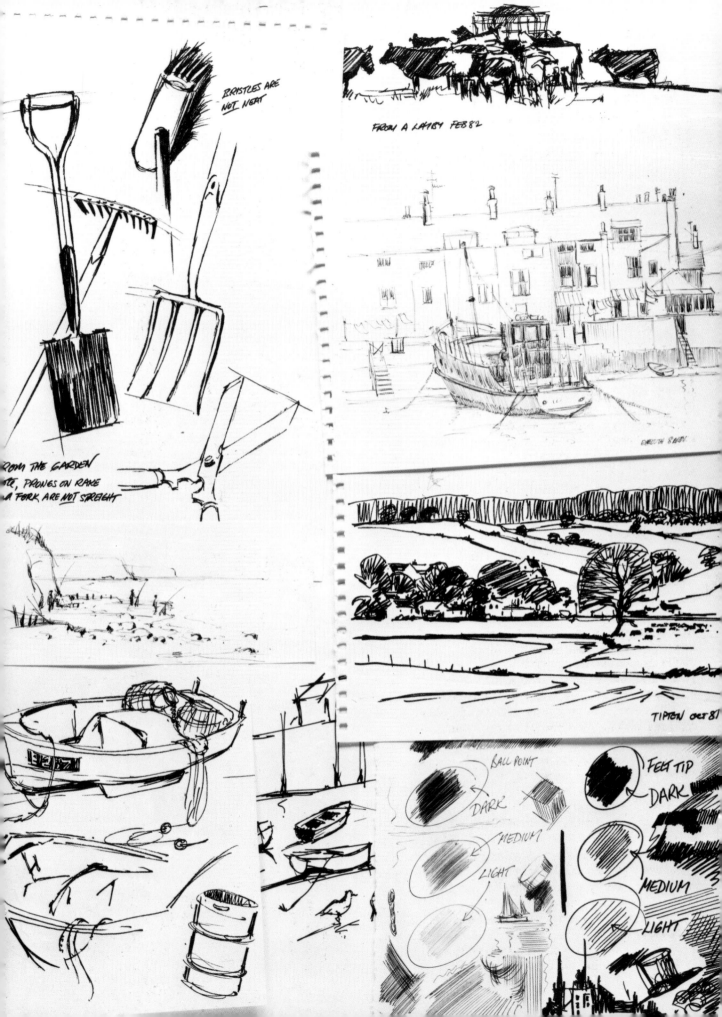

BRISTLES ARE NOT NEAT

FROM A LAYBY FEB 82

FROM THE GARDEN
...TE, PRONGS ON RAKE
...A FORK ARE NOT STRAIGHT

EXMOUTH 8 NOV

TIPTON OCT 81

BALL POINT
DARK
MEDIUM
LIGHT

FELT TIP
DARK
MEDIUM
LIGHT

SIMPLE EXERCISES
IN BLACK AND WHITE

Now that you have experimented with black and white sketching materials and are used to your pencils and pens, etc., we can try some very simple exercises. I have done these in stages to show you how I work. The stages are simulated – I have simply drawn them three times from one-to three as in the first pencil sketch in **fig. 45**. But in the six exercises starting on page 48 each stage is of the *same* sketch and was photographed as I drew it, so you can see the *exact* work that was put into the sketch and how it progressed through to the finish.

The first two exercises are to help you with broad pencil treatment. Use a 3B pencil held in the 'flat' drawing position to give you broad shading for the tonal work (see page 22, **fig. 35**). Start the first exercise by drawing in the line of the field, then put in the buildings (the centre of interest), and follow my stages. Then try the second exercise. Don't labour your pencil work on these exercises, make your pencil work freely trying for light against dark (strong contrast) with shading. All the sketches on these two pages are half as big again as they are reproduced here. **Figs. 45** and **46** were done on layout paper.

Fig. 47 I also did on layout paper, but I used a fountain pen to draw with. Let your pen be as free as you like but go through the stages as I did and you will get the 'feel' of how a sketch builds up. You can try any of these sketches with other black and white mediums. It will make very interesting experiments and it might help you to see which subject suits which medium. For instance it would be difficult to get the atmosphere in the second exercise in **fig. 46** if you used a fine nibbed pen. The sky would be scratchy and difficult to make very black, but with charcoal it would work well.

The last exercise, the hedgerow trees in **fig. 48**, was done on cartridge paper with a stick of charcoal. As I explained in the section on charcoal, it is for broad adventurous treatment, but this simple sketch shows how it can be used for fine work as well so it has greater depth than we might at first give it credit for. Work the trees from the bottom upwards and outwards, in the direction of their growth.

These exercises should be useful. They will have made you copy something, which will help you to observe nature when you are out sketching. The more you sketch the more confidence you will have. Whenever you have 10 minutes to spare – sketch.

Where there's a will there's a sketch!

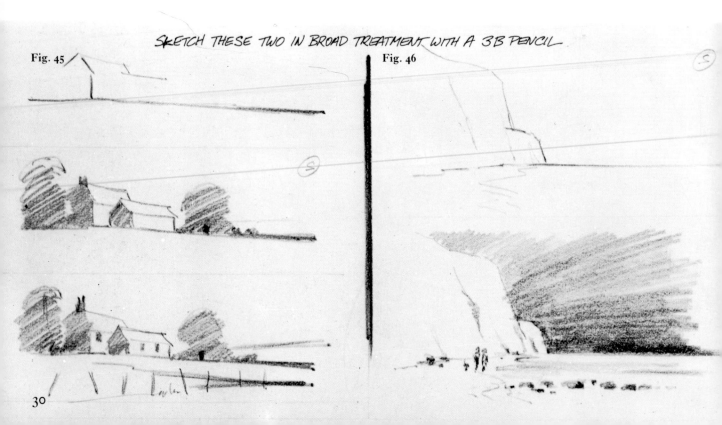

SKETCH THESE TWO IN BROAD TREATMENT WITH A 3B PENCIL

Fig. 45

Fig. 46

Fig. 47

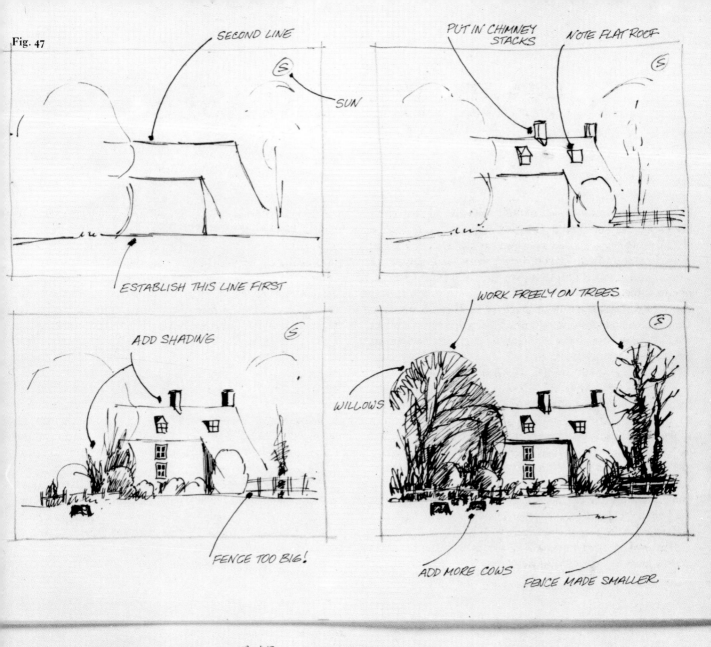

SECOND LINE

PUT IN CHIMNEY STACKS

NOTE FLAT ROOF

SUN

ESTABLISH THIS LINE FIRST

ADD SHADING

WORK FREELY ON TREES

WILLOWS

FENCE TOO BIG!

ADD MORE COWS

FENCE MADE SMALLER

Fig. 48

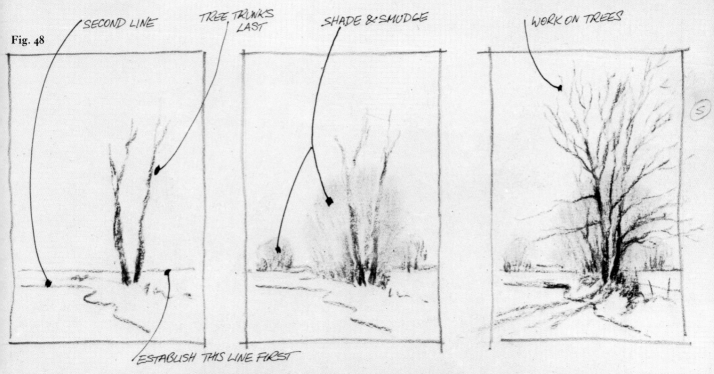

SECOND LINE

TREE TRUNKS LAST

SHADE & SMUDGE

WORK ON TREES

ESTABLISH THIS LINE FIRST

WORKING IN COLOUR

In this sketching book we use watercolour and pastel. Over the next few pages I hope to put you on the right road, give you inspiration, and take some of the mystery out of using colour, but if you want more guidance other books in this series cover each medium in greater detail: *Learn to Paint with Pastels* by John Blockley and *Learn to Paint with Watercolour* by Alwyn Crawshaw. First let us look at colour. It is all around us in our daily lives. It can make us happy, it can give the effect of cold, warmth, dark or light, and yet *all colours* that we paint with are made up from only three: red, yellow and blue. These are called primary colours. I have also added a different red, yellow and blue to give greater scope to our mixing (**fig. 50**) as they are colours that can't be mixed from others.

The next stage is to learn how to mix them to obtain different colours. You will see in **fig. 50** that I have mixed primary colours to make other ones. In watercolour painting you use more water and less paint to make your colours lighter. To make them darker use more paint and less water. I don't use black, only because I was taught not to as it is a dead colour. If you *mix* a black it is much more alive. However many artists do use black, so don't be afraid to use it if you want to, but be very careful.

Watercolour is a good medium to learn to paint with. Some students believe oil is better because you can paint over or rub out your 'mistakes'. This is important for the beginner to be able to do, and of course the choice is yours, but I reason that watercolour, although it is difficult to control, is good to *start with* for two reasons.

First, whether we were artistic or not, most of us were taught to paint with water-based paints at school or even before, usually with poster paint (in jars) or powder paint (in tins, which had to be mixed with water). As both of these types of paint are water based the materials are cleaned in water too. Many of us will have painted on all kinds of paper, everything from brown wrapping paper to the back of old rolls of wallpaper. So a beginner to painting, at whatever age, does not feel alien to watercolour paints, because at some time he or she will have come into contact with them.

Second, it is a very convenient medium to use indoors to practise with. Getting out a paintbox and working in a corner of a room is relatively easy, and there is no smell. Unfortunately most beginners have never come into contact with oil paint before, so don't know how to apply it to paper or canvas, and because of the mixing mediums, it smells of oil and turpentine. I love the smell but it does

Fig. 49

32

not always mix well with the smell of Sunday roast! But this isn't a problem if you have a separate studio.

I am asked so many times by potential students, what to start with and, if pressed, my answer is watercolour, if starting from *the beginning*. Once you have got a grounding in colour mixing and brush handling then try any medium, there is one that will suit your personality and ability, more than any other. Try mixing colours to see what you get. The results may surprise you and I think you might find it easier than you thought. The more difficult colours to mix are the subtler ones, and these will only come with practice and observation.

When you are out sketching with watercolour, try not to get too involved with subtle colours at first, go for broad areas, using colours that are simple to mix. Time and experience will broaden your colour range. When you are out in the country look into the distance, covering up the foreground fields with your hands. Then look at the foreground fields. The colour in the distance is blue compared to the green of the foreground field. In general, the distance is bluish, and the foreground is warmer and has more real colour. Look at a brick wall or the side of a red-brick house. The colour is there strong and bold. Now look at a brick wall or house in the distance and the red colour pales to a red-grey colour. When you are out look for these colour changes, observe them in your sketches and you will find that the background stays in the distance, and the foreground in front; your sketch will have meaning and come to life. In general, to make your colours cooler, add blue and to make them warmer, add red.

When you practise mixing colours indoors look at the objects around you and try to match the colours. Remember that one colour can look different against another, so if you are painting on white paper and your colour is not quite there (say you were copying the colour of a cushion on a chair) then paint the colour next to the cushion (the chair for instance) and you will see a difference, and so on. At this stage don't worry about shapes, just paint splotches of colour. Doodle as I have done in **fig. 49**.

Try working with pastel in the same way, mix the pastels into each other on paper to get the colours required. As there are so many different shades of pastel you can use, mixing is not so important, but pastels can be mixed on paper to obtain different colours, which makes it a very exciting medium to work with. Fix your pastel paintings when they are finished to stop them smudging. I suspect most of you haven't tried coloured pencils since you were at school, so why not try them again for sketching? You will find, to a certain extent, you can mix one colour on top of another to change it. Look at my doodles.

The sketching sets for both pastel and watercolour are illustrated on page 20, **figs. 29** and **30**. The coloured pencils I have used are Rowney Victoria coloured pencils.

Finally to be able to paint your sketches, you have to train yourself to observe colour, and to be able to mix the colours observed. This can't be done overnight, but with practice (make it enjoyable – don't labour your practice sessions) you will find it will come right and, probably, sooner than you think. Doodle, practise and doodle! Good luck.

Fig. 50

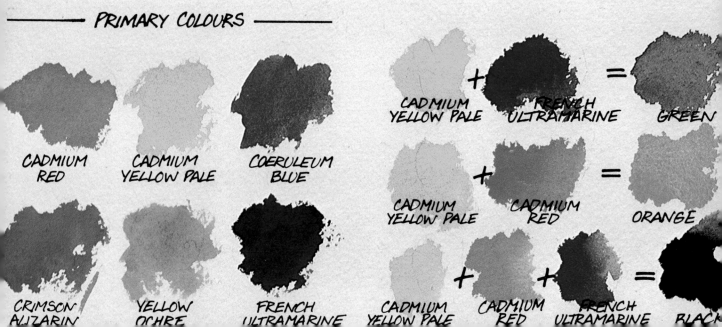

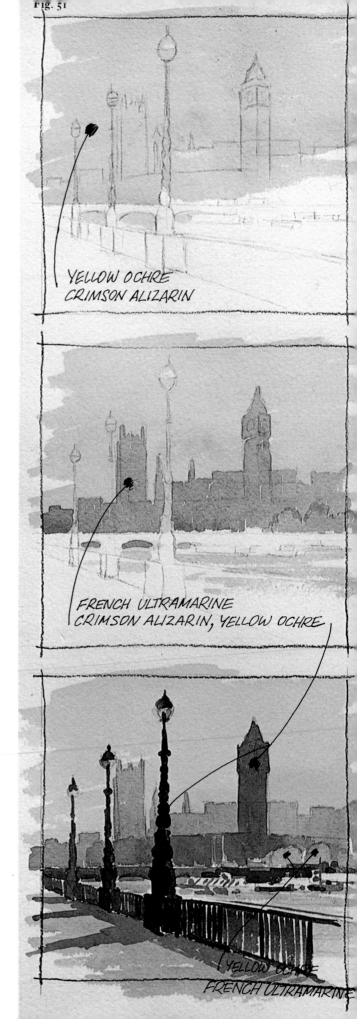

SIMPLE EXERCISES
IN COLOUR

Now that you have practised colour mixing and doodling, you will be ready to try some simple exercises. Don't let the exercises on these two pages worry you because they have shape and form, and seem a far cry from the coloured shapeless doodles you have been working on so far. For instance if you look at the small rowing boat on the opposite page, the first stage is a shapeless doodle of two colours and the second stage only gets its boat-shape by adding one darker tone in the correct places. This comes from *observation* of your subject, but you can see how to simplify objects and still make them appear three-dimensional.

Take this a little further and look at the wheelbarrow below. As you gain confidence you will find that you can put the second tone in (the shadow side of the wheelbarrow) as you paint in the first stage. In other words you would paint in the light area on two sides and then paint in the other two sides with a darker tone. In this way you miss out a stage. When you are painting complicated subjects you will find that this happens throughout the picture. If you find short cuts that enable you to work better, use them. Painting is very personal and we all have our own special ways.

Now let us look at **fig. 51**. This is basically an atmosphere sketch. Any detail needed could have been drawn on a separate piece of paper. I worked in flat washes from the sky to the foreground. I am not certain that the foreground shadows are absolutely correct! I added these at the end at home to show how the shadows create the illusion of the flatness of the ground. As you can see I used only three colours for this exercise, but I decided to use a fourth, Cadmium Red, just for the London buses on the bridge. I worked on a sheet of Greens RWS watercolour paper Not surface. The sketches on the opposite page were done on cartridge paper and all those in this chapter were painted half as large again as they are reproduced here. *Concentrate on working simply at first.* This is especially important when you are out sketching.

The sketch of the church (**fig. 52**) was done with coloured pencils on tracing paper. Only three colours and black were used; and the black was used only to tone down some of the colours and to add detail giving the sketch depth. I used pastel on layout paper for the sketch in **fig. 53**. When I painted in the cows I smudged them together with my finger and picked out more detail at the next stage. I added the sky and rubbed gently over the distant fields. (The cows were in the snow.) This is an atmosphere sketch.

fig. 51

YELLOW OCHRE
CRIMSON ALIZARIN

FRENCH ULTRAMARINE
CRIMSON ALIZARIN, YELLOW OCHRE

YELLOW OCHRE
FRENCH ULTRAMARINE

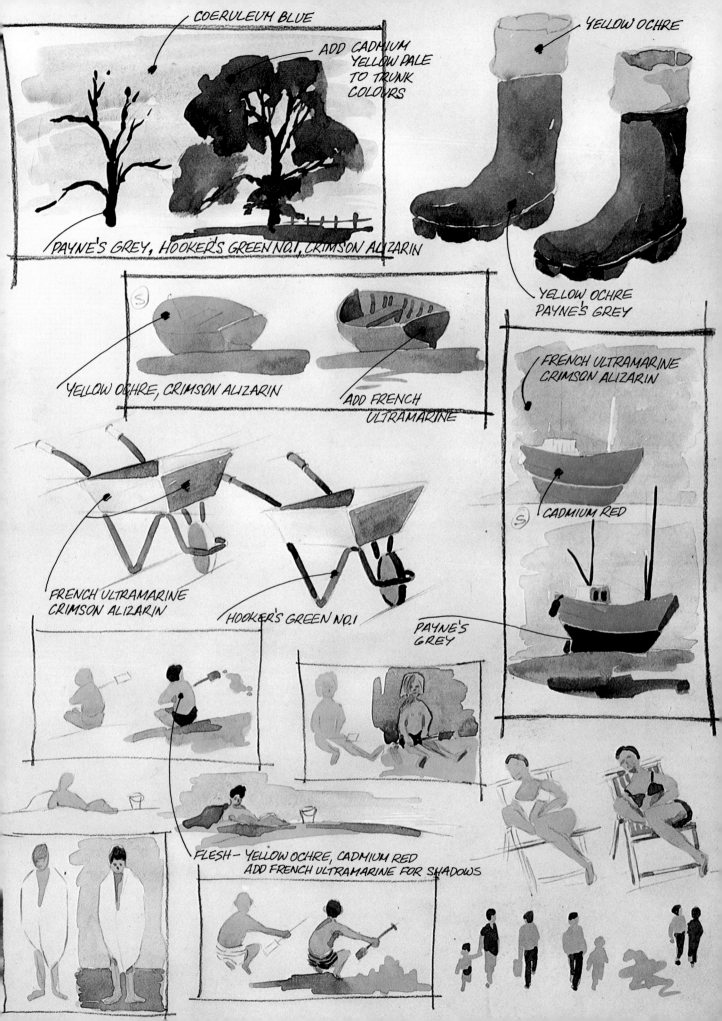

COERULEUM BLUE

ADD CADMIUM YELLOW PALE TO TRUNK COLOURS

YELLOW OCHRE

PAYNE'S GREY, HOOKER'S GREEN NO.1, CRIMSON ALIZARIN

YELLOW OCHRE PAYNE'S GREY

YELLOW OCHRE, CRIMSON ALIZARIN

ADD FRENCH ULTRAMARINE

FRENCH ULTRAMARINE CRIMSON ALIZARIN

CADMIUM RED

FRENCH ULTRAMARINE CRIMSON ALIZARIN

HOOKER'S GREEN NO.1

PAYNE'S GREY

FLESH – YELLOW OCHRE, CADMIUM RED ADD FRENCH ULTRAMARINE FOR SHADOWS

If I had wanted details of cows, I would have drawn them in pencil first and made the sketch larger.

For the sketch on page 37, **fig. 54,** I worked on Greens De Wint 90 lb Rugged paper. It has a very rough surface and is a pale yellow ochre colour. I used only three watercolours and eventually finished off the sketch with a fountain pen.

In **fig. 55,** I used cartridge paper again. It is very important to get used to working watercolour on cartridge paper, as often you may be in a position to draw a sketch in pencil on cartridge paper and then want to add notes in watercolour.

I have worked *very freely* with this sketch, but there would be enough information for me to work a larger picture from it in the studio. Never forget *you* decide what your needs are for an information or an atmosphere sketch. We all see and feel differently about nature. When you sketch outside, never throw any bad ones away, they will always tell you something, even if it's how not to do it again. I have a drawer full!

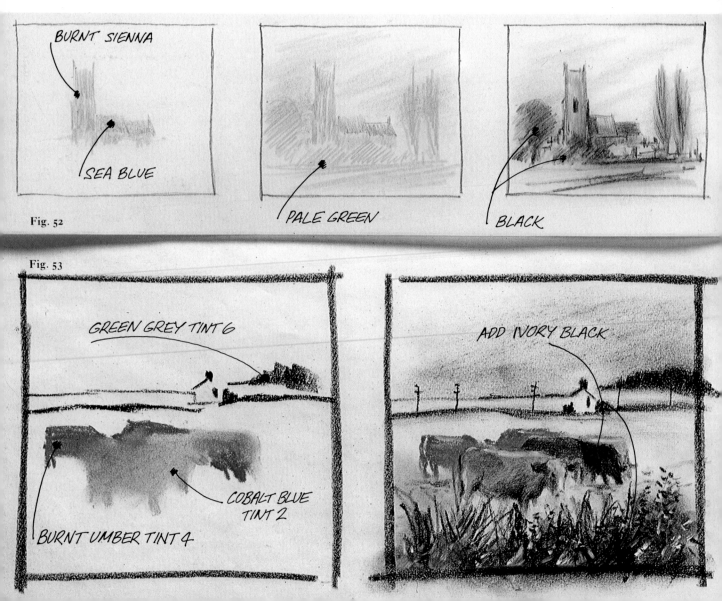

Fig. 52

Fig. 53

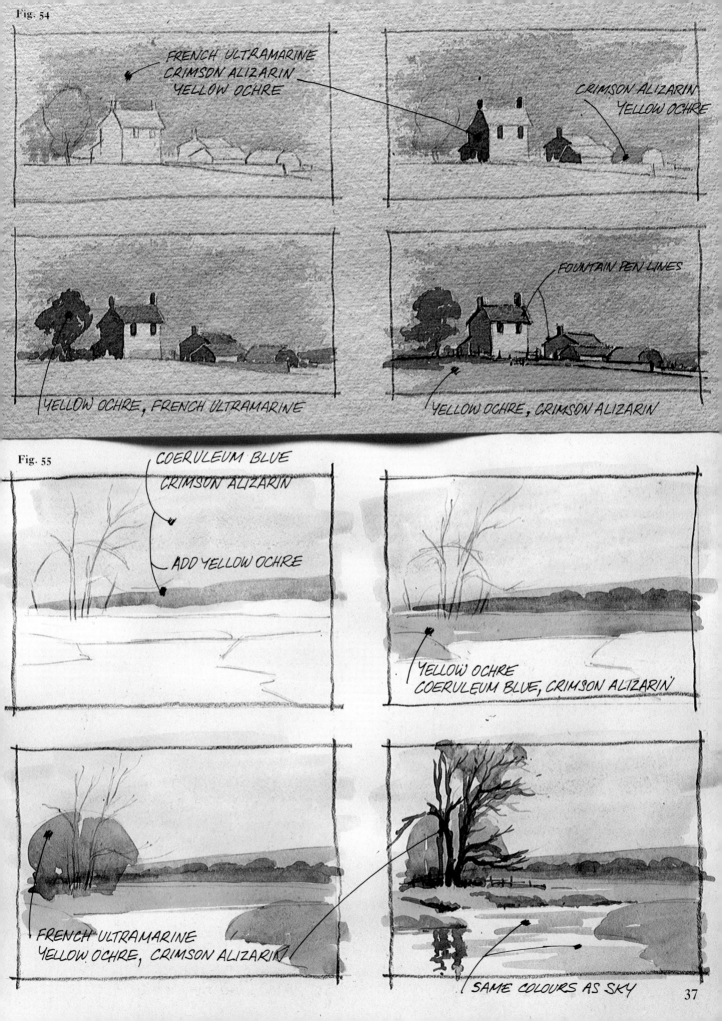

Fig. 54

FRENCH ULTRAMARINE
CRIMSON ALIZARIN
YELLOW OCHRE

CRIMSON ALIZARIN
YELLOW OCHRE

FOUNTAIN PEN LINES

YELLOW OCHRE, FRENCH ULTRAMARINE

YELLOW OCHRE, CRIMSON ALIZARIN

Fig. 55

COERULEUM BLUE

CRIMSON ALIZARIN

ADD YELLOW OCHRE

YELLOW OCHRE
COERULEUM BLUE, CRIMSON ALIZARIN

FRENCH ULTRAMARINE
YELLOW OCHRE, CRIMSON ALIZARIN

SAME COLOURS AS SKY

37

LET'S START SKETCHING

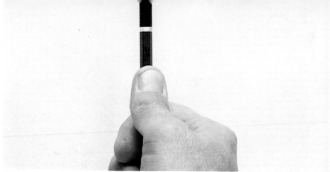

Fig. 56

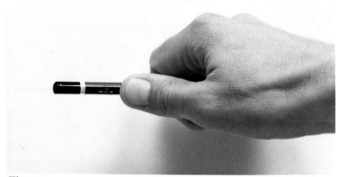

Fig. 57

We have now arrived at what I consider to be the most important section in the book: how to start a sketch. I have discussed already how to find your spot and what materials to take with you, so let us assume you are settled down with your subject in front of you and you are ready to put pencil to paper. First decide what type of sketch you are going to do. The next step can save a lot of time and frustration. If you were to sketch your own lounge, you would be very familiar with it and would understand everything you see because you know it. So, sit on your stool, look at the scene in front of you, and observe. If there are areas that you can't understand, or you can't see properly, move around to different viewpoints until you are familiar with what you are about to draw. This could take up to 15 minutes depending on how complicated the subject is, *but that time used correctly is the most important part of your sketch.*

At this point you might understand everything you see, but how do you work out the relative sizes and positions of objects in your scene, and transpose them accurately on to your paper? If you learn how to 'measure' now, and it is the only technique you learn from this book, then that alone will have made both your and my efforts worthwhile. It is a very important skill to acquire. Although to start with you may find measuring tedious, or perhaps feel it is a little mechanical, you must persevere. It will become second nature and is as much a part of sketching as putting pencil to paper. So how do we do it?

You have all seen the cartoons of an artist looking at his subject holding his arm out with his thumb up. Well, he is measuring his subject. The only difference is we use a pencil. The principle is simple. Hold your pencil at arm's length, vertically for vertical measuring and horizontally for horizontal measuring, with your thumb along the near edge as your 'measuring' marker (**figs. 56** and **57**). Always keep your arm at the same distance from your eye during measuring, or the comparative distances will not be consistent. This is why it is always held at arm's length – it is always easy to find the same position.

Now the object of the exercise is to measure the subject and apply it to your paper. Obviously you do not use the same length to measure your actual subject as you do for the subject on your sketch. You are simply trying to get the correct proportions; so let me take you through an example (**fig. 59**). Draw a part of your sketch, say house no. 3, on to your paper (**fig. 59A**). Now you want to get the houses from 1 to 7 on your sketch as they appear in reality.

Hold up your pencil to measure house no. 3 and as you move your hand along, see how many times the pencil goes into the length of the seven houses. It goes nine times. Check your sketch (**fig. 59A**) and using your pencil on the paper as a ruler, see whether the length of the house no. 3 you have drawn will go along your paper nine times. In **fig. 59A** it only goes about five times. So draw a smaller house on the same sketch (**fig. 59B**) and by simple trial and error you will come to the size of house that will be in proportion to the rest of your picture.

Then holding up the pencil to the real houses measure how many times house no. 3 goes into houses nos. 1 and 2. You will find they are all the same size. Therefore, on your sketchbook, you can measure from left to right, three houses, the third being no. 3, which is our key measure (**fig. 59C**). Looking up at your subject again measure house no. 3 into house no. 4. It goes twice. On your sketch, using your pencil as a ruler, and your thumb as a marker (use the same procedure as for measuring your real subject) measure a distance twice as long as house no. 3 to the right of it and you have the correct size for house no. 4. Carry on in this way until you have your row of houses from 1 to 7 and they will fit your sketchbook exactly, (**fig. 59D**).

Now to check the height of the houses, measure the width of house no. 3 and turn your pencil vertically, with your thumb still in position, and see how many times the width of the house goes into the height. You will find that it fits exactly once, up to the bottom of the eaves. Therefore, on your sketch, use your no. 3 house measure and mark in the height of the houses (**fig. 59E**). Then check the height of the roofs and so on.

If you take time to do this, you can put as much detail and work into the houses as you want, knowing that your drawing will end up on your sketch pad (not falling off it!) and it will be proportionally correct. If you use this method

objects can be placed in the right position on your drawing and in the right position in relation to each other.

Let us take a real example (**fig. 58**). My first key measure would be the stern of the right-hand boat. It goes across the picture approximately six times. Working this out would make sure everything in my picture fitted on to my sketchbook (assuming everything was measured correctly). You can see the main features that are the same size as the key measure. I found a half-size key measure (which helps for other measurements) which here is one of the roofs. Put your important subjects into position by measuring and as you draw the rest they should fit into place correctly. When you are measuring don't be too rigid. If an area of your subject measures a key measure and a bit, then draw it on your sketch the size of a key measure and a bit.

If I were to show you how to do this it would take only five minutes, but to explain it in writing may make it seem very complicated to you. Please read it over and over again, until you understand the method, and then practise. Try it when you are sitting at home, you will soon get used to it. Frequent practice will train your eye to see the size of objects in relation to each other and to be able to place them on your sketch pad correctly. *This is a very important lesson.*

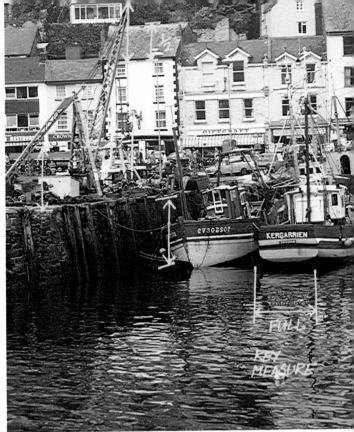

Fig. 58 An example of the use of key measures in working out the correct proportions of your sketch

Fig. 59

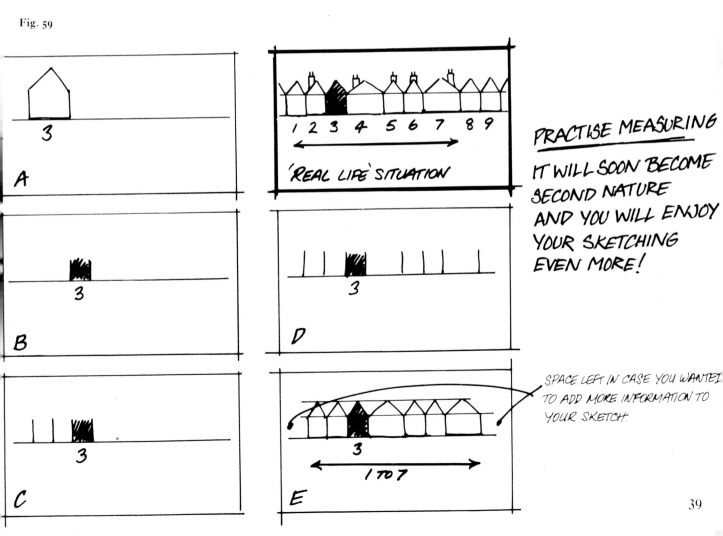

PRACTISE MEASURING

IT WILL SOON BECOME SECOND NATURE AND YOU WILL ENJOY YOUR SKETCHING EVEN MORE!

SPACE LEFT IN CASE YOU WANTED TO ADD MORE INFORMATION TO YOUR SKETCH.

A SKETCH STEP BY STEP

Now that you know how to start a sketch let's go through the development of a simple sketch to see how it works. At this stage you have observed your subject, you are sitting or standing comfortably, you know the type of sketch you are going to do, you can measure, and finally you have decided what your centre of interest is.

Now I shall take you through the stages. First look at stage 9, the completed sketch, to familiarize yourself with the picture. Then start at stage one. The first line to draw is the line of the main field. Position this near the centre of the page then you can add more foreground or sky later. I wanted this picture to be long and thin, as it was the long line of the farm buildings which inspired me to draw this sketch. In stage 2 position your buildings (the centre of interest) and draw them in stage 3. Now in stage 4, complete the buildings emphasizing the lower part of them so they don't appear to float off the hill, and draw in the new field. In stage 5, put in the background hills. Draw the tree in stage 6 and if you look at my sketch, I have drawn two more lines across, one above the buildings, and one below. This gives you the long shape of the picture dominated by buildings. It is wise to add more information if you have the time and this I did in stage 7. Stage 8 shows the paths extended and the gate and fence drawn in. This could make a 'happy', designed picture with the path leading you to the centre of interest.

Now that the sketch is finished, was it nature that led me to that spot with the path through the gate? As I said before let nature help you design your pictures. The completed sketch in stage 9 has got only a little more work in than the previous stage, but I have shown a different picture shape by cutting the sketch off just above the tree. So this one sketch can make three different pictures shapes; stages 6, 8 and 9. The sketch was taken from nature, but the sequence of stages was done in my studio to explain, simply, the progress of a sketch. I used a fountain pen on layout paper and each sketch is 15cm (5¾in) wide.

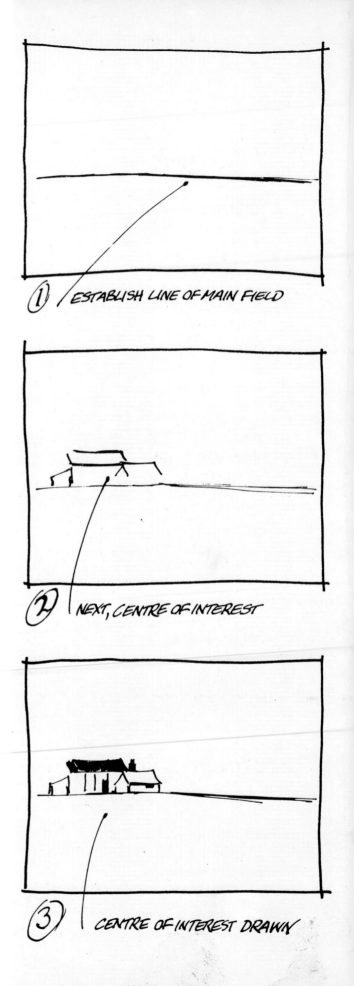

① ESTABLISH LINE OF MAIN FIELD

② NEXT, CENTRE OF INTEREST

③ CENTRE OF INTEREST DRAWN

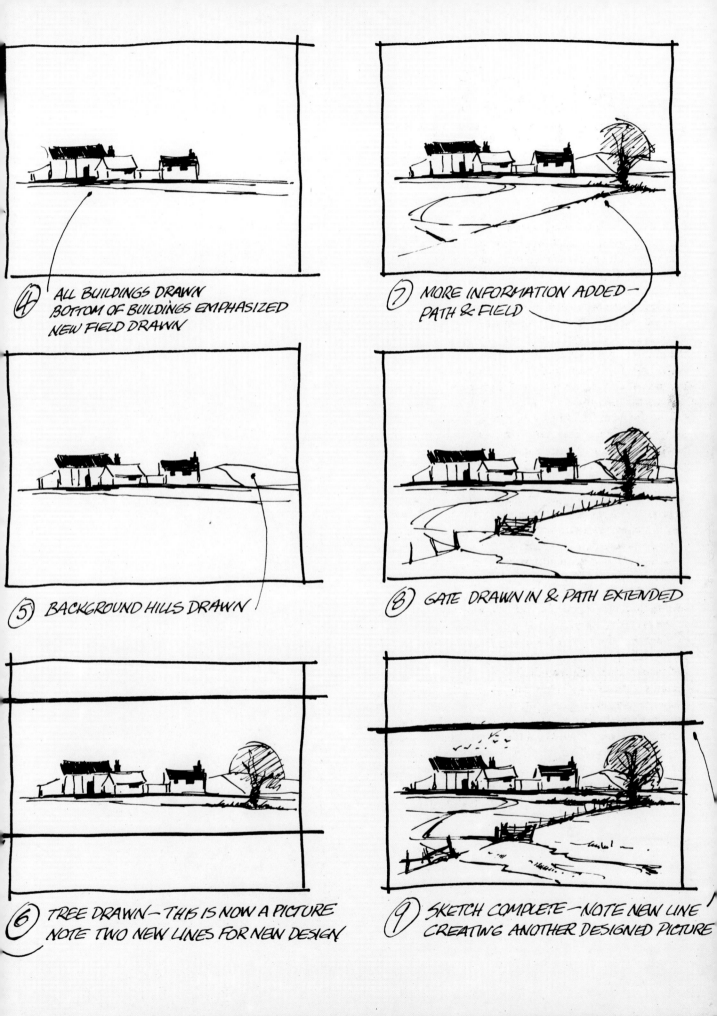

④ ALL BUILDINGS DRAWN
BOTTOM OF BUILDINGS EMPHASIZED
NEW FIELD DRAWN

⑦ MORE INFORMATION ADDED—
PATH & FIELD

⑤ BACKGROUND HILLS DRAWN

⑧ GATE DRAWN IN & PATH EXTENDED

⑥ TREE DRAWN—THIS IS NOW A PICTURE
NOTE TWO NEW LINES FOR NEW DESIGN

⑨ SKETCH COMPLETE—NOTE NEW LINE
CREATING ANOTHER DESIGNED PICTURE

WHEN IS A SKETCH FINISHED?

You stop working on a sketch, when you feel you have been drawing long enough, whether it's because you're tired, hungry, cold or just bored with the subject. You are sketching to enjoy yourself (unless it is a sketch that you have to do). If the enjoyment goes, then start another one or go home. This is sound advice if you are tired.

On one occasion I had been sketching for most of the day by a river estuary, I was feeling very tired, a little cold and ready to go home, when I saw a group of boats that caught my eye. I thought they would make a perfect group and decided to do a 'quick' sketch – the last one before going home. (Incidently *there is no such thing as a quick sketch*, *unless it tells a story*.) Well the result was disastrous. You can see it on the opposite page (**fig. 63**), I still can't make sense of it even now. It went wrong because I had tried to work fast. There is nothing wrong with that, but my brain was tired and didn't *observe*. I drew it without 'seeing'. Unless you observe, your drawn lines become meaningless. As a rule of thumb, you stop when you have got the information on paper that you are after.

The two watercolour sketches in **figs. 60** and **61** were both done on Greens RWS 1401b Not surface watercolour paper, 38×51cm (15×20in). The one in **fig. 62** was worked on Bockingford paper from a sketch pad, 30×41cm (12×16in). It was done very freely but I still have enough information to work from. For watercolour I call the sketch in **fig. 62** a pure sketch, while the other two turned from a sketch into a painting. In the pencil sketch in **fig. 64**, I have made the distance work for me, but the middle distance and foreground are confusing. This is because I used shading over the drawing. I should have stopped work on that sketch before I shaded the foreground.

The sketch in **fig. 65** is ideal. It is open pencil work and I have left the wintery trees unfinished so I could get information on to the sketch of what was going on behind them. I made colour notes on the sketch and would be very happy to work from it in the studio to paint a picture. The sketch in **fig. 66** is what I consider to be my normal information sketch, which usually has line work and tonal shading. On this one I didn't do a colour code so you could see the sketch better.

You can see from my examples, on one of them I didn't put enough work (**fig. 63**), in another (**fig. 64**), I put too much work (shading) and with the other two pencil sketches, I was very happy. As with the watercolours, two look like pictures, and one like a sketch. You may prefer the less painted one – it is really a matter of personal preference as to how 'finished' you like them. The rule is, stop when you have what you set out to get: enjoyment, information, atmosphere, or all three!

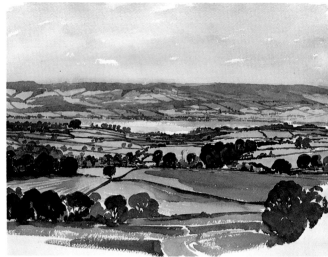

Fig. 60

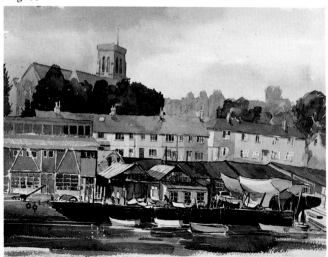

Fig. 61

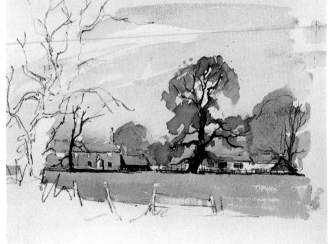

Fig. 62

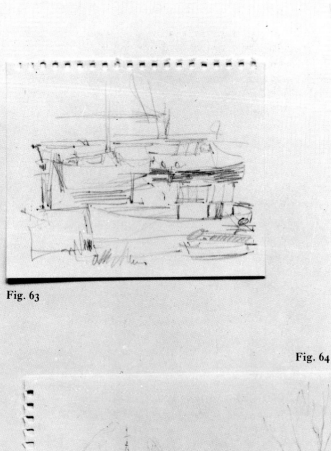

Fig. 63

Fig. 64

Fig. 65

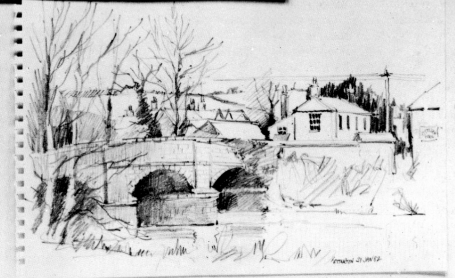

Fig. 66

QUESTIONS ANSWERED

I decided it would be a good lesson from which you can benefit if I were to present three of my sketches to a group of artists and students so they could question me about them. I haven't included some questions that have been covered in other parts of the book.

Where did you start the sketch of Windsor Castle (fig. 70)?
I positioned the tower on the paper and worked out its size by measuring to make sure that I would get enough of the castle to fit on the page. Then I positioned the water level of the river.

Why did you put the tower in the middle of the picture?
I started with the centre of interest – the tower – and worked on either side of it. (If you are going to paint from it at home you can decide where you want your centre of interest then.) As it happens I like the composition of the sketch, because the tower and the flag give it a pyramid shape making the castle look solidly placed on the ground.

I would never think of drawing a mechanical digger, what inspired you to do it (fig. 69)?
I was out sketching in February after a very severe winter, and as I walked up the road, I saw the digger. Half the road had disappeared and there was at least a 50-foot drop where the road had been! I had never seen anything like it before and sat down in the middle of the 'road' to record it. It was a typical enjoyment sketch, it was so unexpected and exciting, and it is now on paper for ever.

How do you scale up (or down) a sketch to get the correct proportion of paper or canvas, for a larger picture at home?
Well the diagram in **fig. 67** shows you how. Use a ruler, or a straight edge of some kind if the ruler isn't long enough, and draw a line diagonally across the page from one corner to another. Wherever you draw a line parallel with the top of the sketch page to meet your diagnonal line, drop a perpendicular line down, parallel to the side of your sketch page and that area will be exactly in proportion to your sketch. The beauty of working your proportion in this way is, it's simple, and you can get any size you want. Try working this method on some scrap paper to get used to it and you will see that you can also work a large sketch *down* in proportion.

What inspired you to sketch the landscape (fig. 68)?
I was not so much inspired as commissioned. It is a view near Clyro in Wales which I did in the spring. I had four glorious days sketching in the area and eventually worked on four large canvases, 61 × 91cm (24 × 36in) which I enjoyed, and in this case more important, my client liked them also. On this sketch I worked on cartridge paper using pencil first, then watercolour, then felt pen.

Where did you start?
I established the hills furthest away and then the distinct hillside of trees running down from the centre to the right-hand side of the picture.

Is the hillside covered in trees, or not?
This is a very reasonable question because from the sketch it is difficult to say what the dark area is. It is a hillside of trees, but because it is a sketch and *I know* they were trees (or the information was clear to me) then it did not matter.

Where did you start the sketch of the digger (fig. 69)?
I positioned the mechanical digger first but made sure I had enough room for the breakaway of the road, which is what provides the drama of the sketch.

Is the sketchbook size of the top and bottom sketches, 29 × 41cm (11½ × 16¼in), a good size for you to work on?
Yes, for large subjects. The middle sketch was 21 × 29cm (8¼ × 11½in) and this is a good general purpose size for me.

Why haven't you finished what appear to be trees on the bottom left-hand side of the sketch in fig. 68?
Yes they are trees, but after drawing in the first two to give size and depth to the sketch, I knew they were trees and didn't bother to put any more in.

How important is sketching?
It teaches you to observe. It takes you out of doors to see and feel nature and to record. It is the life blood of your inspiration. If you can go out sketching – then you must.

Fig. 67 This shows you how to scale your sketch up or down to any size you want while retaining the correct proportions of your original sketch in your finished painting

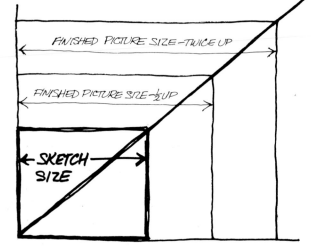

FINISHED PICTURE SIZE – TWICE UP

FINISHED PICTURE SIZE – ½ UP

← SKETCH → SIZE

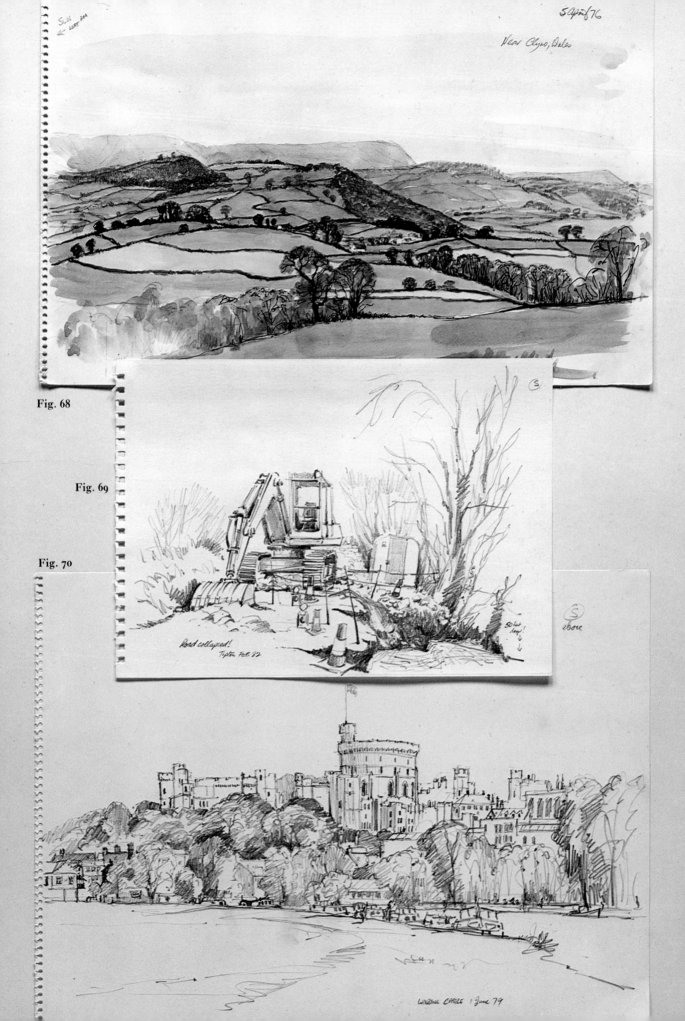

Fig. 68

Fig. 69

Fig. 70

NOTES ON SKETCHING MOVEMENT

When you are learning to sketch you must think that there are enough complications sketching something stationary without trying something that moves. So let us take the important stages of drawing a sketch and see how they work for a moving subject. First you have your subject, you are seated or standing comfortably and you know the type of information you are looking for. The next stage is to observe and understand your subject.

If anything, this is even more important for capturing movement. Measuring is important, but it can be very frustrating; particularly when, for instance, you measure the length of a horse's head to see how many times it goes into the body length, and it changes position.

I have tried to think whether I have a magic formula that I use when I draw a moving subject but unfortunately the answer is no. Nevertheless there are certain ways of approaching your subject that will enable you to master this part of sketching. The most important priorities are practice and self-control followed by observation and understanding of your subject. When you have spent five minutes drawing a horse and it casually walks away before you have finished working on, say, its hind quarters, it is enough to try anyone's patience.

Assume you are sketching heavy horses. You must look at them and study their most outstanding features. You will find they stand still for minutes at a time. Look for the obvious key positions of their anatomy. Where does a foreleg start, and how long is it compared to the depth of body, and so on. So you are measuring and positioning through observation, *before you start to draw.*

Your observation could last anything from half an hour to an hour. It's up to you, but don't 'draw with your eyes' for too long or you will find it much more difficult to actually start sketching. When you do begin don't rush and go faster than you are capable of working. Carry on at your own speed, observing carefully, and if your subject moves, stop and start with another. You may find that your subject regains its original position, or that another horse takes up the same attitude so you can carry on your sketch using a different model! Never worry that you don't finish one horse completely. You are learning by observing and when you sketch as well, you record what you see. This combination of activities will quickly give you a good knowledge of your subject.

Naturally the more you do, the more your sketches will flow, particularly as you learn more about your subject. If I were to sketch horses for say two hours I would start by spending half an hour wandering around looking and observing, soaking in the atmosphere. The next 20 minutes I would spend sketching. The chances are it would not be very good, but I would be loosening up, relaxing and getting the 'feel' of the subject. For the next hour I would work very hard oblivious to my surroundings, completely involved with what I am drawing. It is from this time that the real information would come. If my sketches work out I am pleased and then my concentration would start to lapse. The results of the last ten minutes or so sketching would resemble those of the first 20 minutes.

If the horses are walking, observe them, and then draw. You will notice the movement and the shapes that keep recurring as they move, and your drawn lines will be dictated by what you have observed. This sounds easy, but if you don't practise it will be very difficult. This applies to virtually any moving subject.

One way of training your eye to retain an image long enough to draw its shape reasonably well, is to sketch movement on your television screen. This is difficult, but it can be done. You won't finish anything and your sketchbook may seem to be filled with unsatisfactory work but these sketches are simply a means to an end. They are a way of training your brain to *work and observe* faster than normal. You will learn to look for and see things that hadn't occurred to you before, and you will need to see in seconds how to simplify shape and form.

People on the beach are interesting subjects to sketch, and you can usually do it in warmth and comfort! When sketching movement it is useful to remember my rules: be patient, observe, look for simple shapes and form, work your speed up, and practise, practise and practise! If you aren't successful in sketching movement, don't worry, stick to the vast range of stationary subjects – so long as you enjoy it!

Opposite are pages from my sketchbooks to show you the type of finish I need for my information. They were not done especially for the book. In fact, the middle pages representing people on the beach were done at Bournemouth in 1976. The horses at the top were my third page of sketches done at a ploughing match near Guildford in 1979. The chickens were sketched very recently and the figures at the bottom right-hand side, were of my family picking mussels off rocks in Brittany.

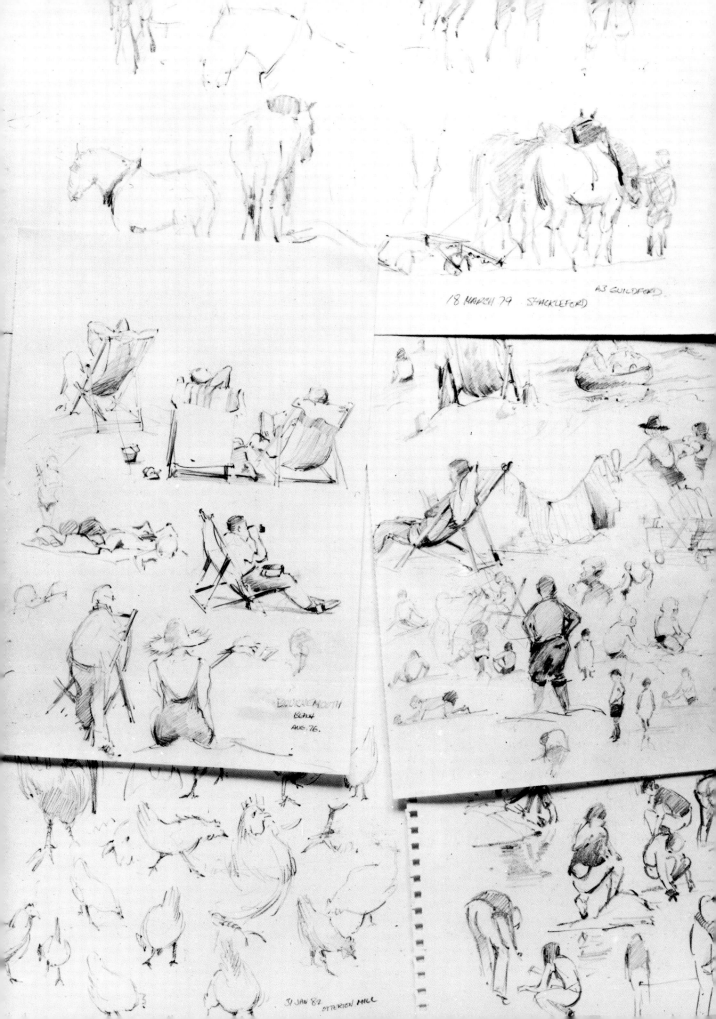

18 MARCH 79 SHACKLEFORD A3 GUILDFORD.

BOURNEMOUTH
BEACH
AUG. 76.

31 JAN 82 OTTERDEN MILL

First stage

EXERCISE ONE
PENCIL

On the following page I have taken six subjects and worked each one through its progressive stages for you to follow and copy. I have sketched these in my own style and it is the way I work. You may find it easier to find your own way, and I have stressed throughout the book, we are individuals and have our own method of doing things, and painting or sketching is no exception. Initially you need guidance in a certain direction to know whether it suits you or not. But when you have more experience you can find your own natural method.

All these exercises I sketched first outside on location, and then sketched in the studio, stopping at each stage so they could be photographed. Thus, the progression of stages is a true one – they are the same sketch. It is important for you to know the actual size of the sketch (not of the reproduction) so you understand its relative scale and the type of paper used, and these are indicated near the finished stage. In each exercise a detail of the finished sketch is reproduced actual size showing how I drew or painted a particular part. Good luck!

First stage Establish the main distant field by drawing a line across the paper with a 3B pencil. Put in the line of hills in the distance and the river. Draw in the rear field line, the path, willow trees on the left bank, and the dark tree in the middle distance to the right of the willow. Throughout the first and second stages hold your pencil in the 'long' position.

Second stage Shade in the distant hills and work from left to right on the trees in the middle distance, starting with the dark tree on the right side of the willows. When you come to the willow on the right-hand side of the river bank, draw in its shape. Let your pencil wander around applying different pressures, forming and shaping the trees, shading and keeping your lines very free. Don't try to copy mine exactly, or you will become inhibited.

Third stage Still working with the pencil in the 'long' position shade the willows in the direction of growth of the leaves and branches, working from the bottom upwards. Keep the shading light where the dark middle distance tree shows against the willow. Darken the trunks with your pencil in the 'short' position, and add the shadow underneath. Now work very lightly to suggest the trees left of the willow. With your pencil in the 'long' position again, draw in the willow on the right side of the river and the

Second stage

Third stage

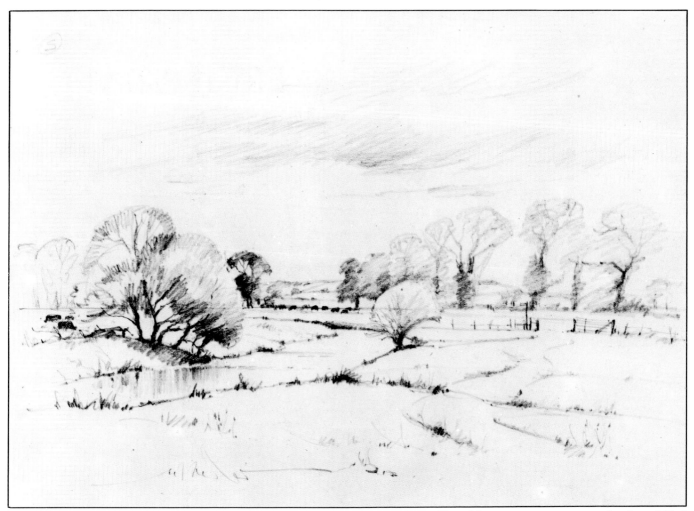

Finished stage Cartridge paper, 29 × 42cm ($11\frac{1}{2}$ × $16\frac{1}{2}$in)

cows in the middle distant field. (As cows move around, normally I would put in the cows whenever they fit well into my sketch, not necessarily at this third stage.)

Finished stage At this stage put in any detail you want, and give form to certain areas. For instance draw in some grass on the left-hand bank coming down to the river and darken the far bank where the river bends to the left. Most of this work is done with the pencil in the 'short' position. Now draw in the gate, fence and signpost. Shade in the reflections in the river with downward strokes and then drag your pencil across the river to give the impression of movement. Now add grass detail, darken the edge of the river and the path. Finally add the couple of cows that have wandered into the field left of the willows and shade in the clouds.

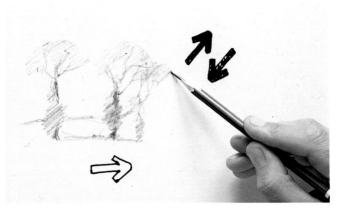

First stage

Second stage

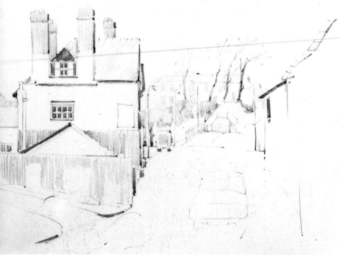

Third stage

EXERCISE TWO
PENCIL

I didn't have to go far to sketch this on location, as it is my local village, Tipton St John. The bridge in the middle distance is over the river Otter and the road just in front used to have steam trains crossing it on their journey from Sidmouth or Exmouth.

The first stage is done with a pencil in the 'short' position. You will know by now that in the 'short' position you have complete control over your pencil for any detail work or carefully controlled drawing. The 'long' position has less control and the 'flat' position has least of all, but it gives the greatest freedom of movement and covering power. I didn't draw in my eye level when I worked the sketch, but I had located it and could refer to it to check anything that might look wrong as I was drawing.

First stage Using a 2B pencil establish the first line to the right-hand side of the Golden Lion with one straight line, then draw in the rest of the building to get the correct proportions. (If you were on location you would measure; see page 38.) Carefully draw the shapes starting at the chimneys and work down towards the windows. Make the right side of the building dark as you come to it. This will anchor your sketch as you continue drawing. Now position the line of houses and trees in the background, and the road and the houses on the right-hand side at the end. Finally draw in the front car and work back fixing the position of the other cars. You might find when doing the first stage that you also establish other parts of the sketch. As you draw in one part it automatically gives you a reference point for another section of the drawing. This is what happens when you are working outside and building up a sketch.

Second stage With your pencil in the 'long' position shade in the background houses and trees. Put in the railings over the bridge and the streetlights on the left. Draw all this keeping the tones light to keep the distance in its proper place. Finally put in the guttering and window of the building on the right-hand side making it dark as it helps to establish the tonal values of the background. Draw the bridge railings and streetlights with your pencil in the 'short' position.

Third stage Now the sketch is firmly set on the paper, put detail work on the Golden Lion. Hold your pencil in the 'short' position. Divide the windows up with faint pencil lines, then shade in the dark window panes individually. Don't try to make the shading an exact shape, or it

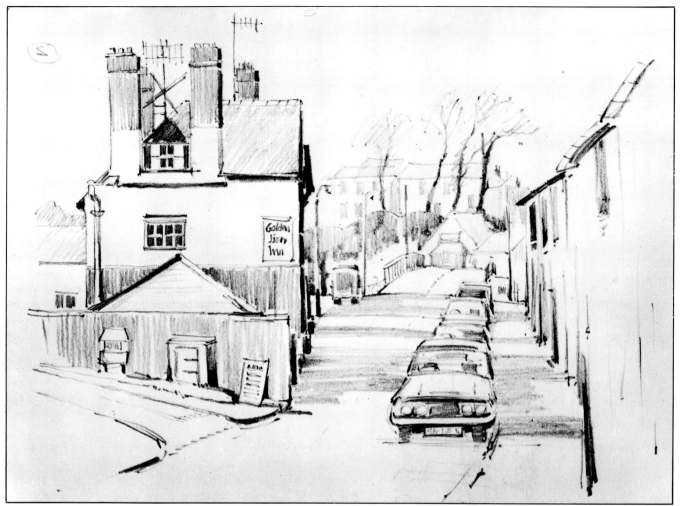

Finished stage　　　　　Cartridge paper, 21 × 29cm (8¼ × 11½in)

will lose some of its character. (See the close-up illustration.) Shade the chimneys, the roof and the walls with the pencil held in the 'short' position. The pencil must have a chisel-shaped point to give a broad stroke (see **fig. 22**, page 18). Also shade in the wall in front of the inn and put an edge to the road going off to the left.

Finished stage　Now draw in the three objects in front of the wall. One is the menu board, the other, I think, is an

electricity box and the third is some kind of ornamental feature. (If I had wanted any more reference to these items I would have sketched them separately in detail.) Next draw the cars (all this is with your pencil in the 'short' position) then indicate the buildings on the right. Because they are very foreshortened, they appear simply as dark and light shapes. Put in the television aerials and sketch in the shadows across the road, holding your pencil in the 'long' position.

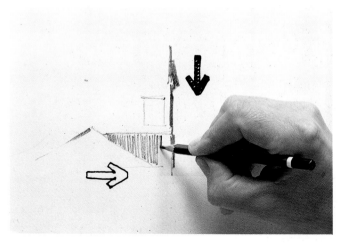

EXERCISE THREE
CHARCOAL

First stage

Second stage

Third stage

I must confess, as I have worked more than I normally do with charcoal while doing this book I have come to like it more and more. But in my experience it is most suitable for landscapes which is why I have chosen hedgerow trees for this exercise. It makes nature seem undefined, and yet complete. In the charcoal sketching set, I didn't illustrate a fixative spray as the attraction of charcoal is the simplicity of the equipment. As a compromise I keep one in the car, so that when I have finished sketching I can spray my sketches before setting off home. This exercise is very simple and only took about half an hour to sketch, but I hope it will show you the beauty of charcoal drawing. I used a charcoal stick about 6cm (2in) long. Hold your sticks in the 'short' and 'flat' pencil positions. The 'long' position could break the stick.

First stage First establish the line of the hill, the road and then the background trees. Start the trees from the bottom upwards, drawing the branches in the direction in which they grow.

Second stage Now draw in the large foreground tree by scrubbing the stick up and down the trunk to get the density you want; you will find that the cartridge paper grain also helps in giving 'bark' texture to the trunk. Work the branches outwards in the direction of growth then put shading to the right of the tree to bring in some shadow.

Third stage This stage introduces one of the delights of charcoal—smudging. It enables you to get tone over large areas and by working on the area and adding more charcoal, you can build up the tonal work and get plenty of depth into your sketch. Now, for the hedgerow trees, use your first finger to smudge the background trees together and in places, over the front tree. If you find the tone needs to be darker then draw more charcoal over the trees and smudge it in. If you look at stage two it only takes seconds to get to stage three, but notice the depth and atmosphere you have achieved in those few seconds.

Finished stage Draw the background trees again, daintily, over the original ones. Try dragging the stick across the paper to get a slightly different branch effect. Then draw in the main tree and add more branches working some over the smudged area. As you do this, you will see how the smudged area recedes and the main tree seems to come forward. Add the shadows across the road, put in some accents on the road edge and, finally, put in the fence.

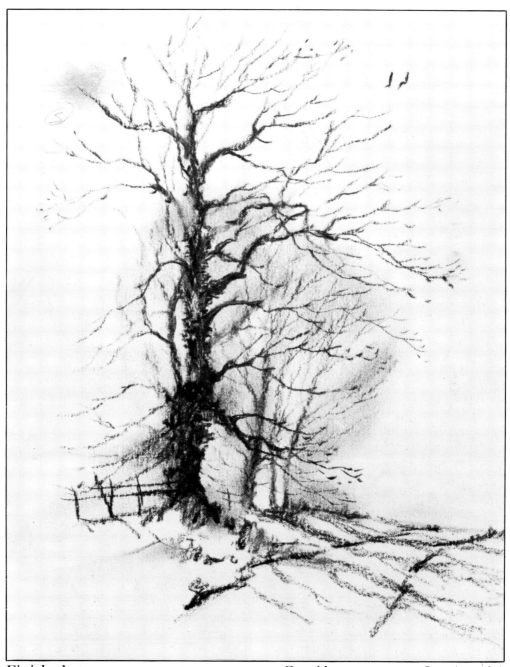

Finished stage Cartridge paper, 23 × 18cm (9 × 7in)

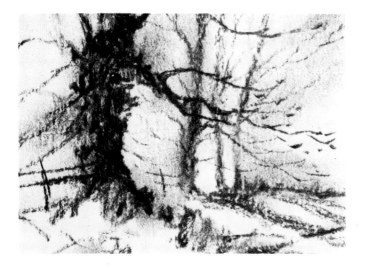

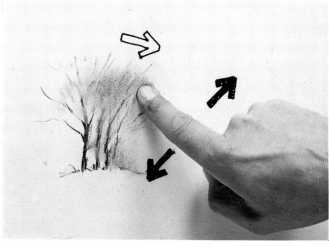

First stage

Second stage

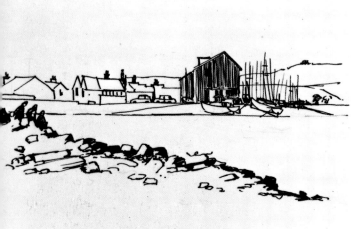

Third stage

EXERCISE FOUR
PEN

This sketch was done near the spot I worked the Exmouth sketch from on page 6. I like the area very much for painting and I have sketched it quite a few times in many different moods. Variety is one of the great advantages of an estuary area; the scene is constantly changing with the tide going in and out and boats changing positions – new ones coming in, and always plenty of activity. It must be a natural place for any artist. I did the sketch on location directly with a fountain pen, but for this exercise I drew it in first with a 2B pencil. This was only as a guide as I was working from a sketch, not the real thing. I worked on Ivorex board.

First stage In this exercise we start from the centre of interest. Locate the water level on your paper and draw it in with your fountain pen. You can draw the main parts of the sketch with your pencil first, but if you feel confident, try using a fountain pen straightaway. Next draw in the top of the quay and the boathouse, and shade it in downstrokes with the pen. Then draw in the boats in front of the boathouse.

Second stage Draw in the hills in the background and the water line to the right of the boathouse, then the houses to the left and the cars. Working to the right of the boathouse, create an impression of an untidy group of boats by letting your pen move freely. Draw in the masts making sure you draw these in at different angles, some straight, some leaning (see the part of my sketch reproduced actual size).

Third stage Now draw in the rocks at the edge of the water. Start at the top left-hand side and work down to the bottom right. Shade in the rocks as you work and keep most of them dark against the water. As you work down put in the three figures when you come to them.

Finished stage Draw in the telegraph poles on the quay, the yacht masts, people on the quay and the little boats at the edge of the quay. Now shade in the distant hills and draw in the foreground boat. Treat the reflections very freely, working the pen in horizontal strokes, backwards and forwards. For the boathouse reflections, masts and telegraph pole draw the pen line vertically starting at the top and working in a free wiggly stroke downwards. Add a few horizontal strokes to the left of the boathouse to give the impression of water movement. Finally put a little more work into the beach and rocks.

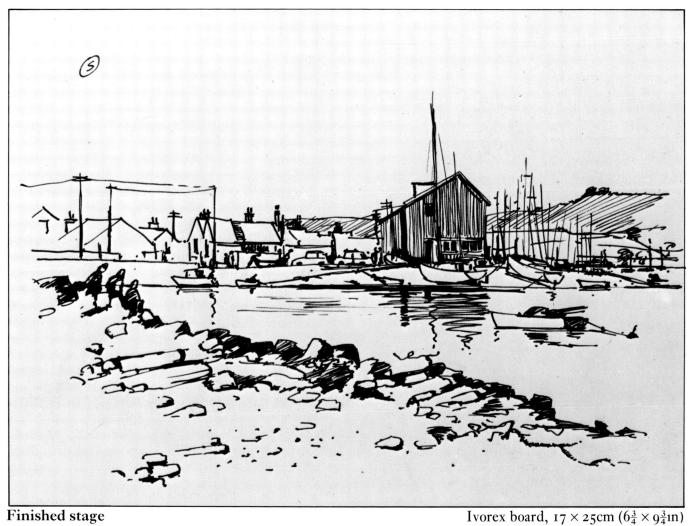

Finished stage Ivorex board, 17×25cm ($6\frac{3}{4} \times 9\frac{3}{4}$in)

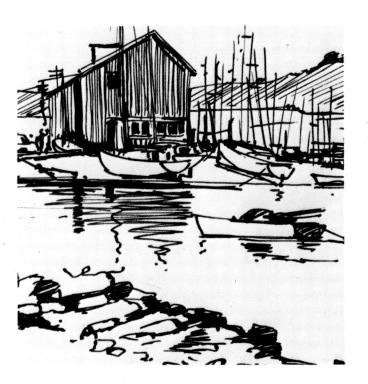

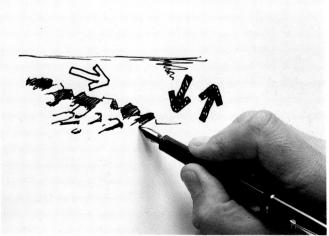

EXERCISE FIVE
WATERCOLOUR

It was late afternoon at Widecombe in the Moor, the sun was going down over the hills and that misty half light that seems to merge shapes and create mysterious silhouettes was descending. I was inspired to sketch this scene by the outline of the tree against the church.

First stage First draw the picture with an HB pencil. Wet the sky area down to the roof tops with clean water using a size No. 10 sable brush. Mix a wash of French Ultramarine and Crimson Alizarin. Work this into the sky first and as you work down, add a little Yellow Ochre. Then add Cadmium Yellow Pale and work over the hill and down to the roof tops.

Second stage When the sky is dry use the same brush and a mix of the same colours to paint in the distant fields on the right-hand side and the houses just below. Still using the same colours, only stronger (by mixing more pigment and less water) paint in the church steeple. Start at the top and work down. Change your mix of colours as you paint, to give it some life. Then work left and right of the steeple painting in the houses. Don't paint over the windows, leave the paper showing through. While this is still wet mix some Hooker's Green No. 1 with your colour and paint in the grass in front of the church allowing it to touch the wet paint and run in places.

Third stage Now with your size No. 6 sable brush mix French Ultramarine, Crimson Alizarin and Yellow Ochre, and paint in the wall. Leave white areas showing through and try to paint the wall stone by stone. A lot of them run into each other but this will give the effect of a stone wall. Mix Hooker's Green No. 1 with your colour and paint in the grass verge, and with a little Yellow Ochre and Crimson Alizarin put in the road. Mix French Ultramarine, Crimson Alizarin, Yellow Ochre and Hooker's Green No. 1 making a strong dark tone and work in the tree at the back. Work from the bottom and keeping the paint wet, work up the trunk and out to the branches. While the paint is still wet drag a dry brush back into the branches to give the feathery effect of small branches. (See the detail on page 57.) While it is still wet, paint in some small branches with your Series 56, size No. 2 sable. When the whole tree is nearly dry, start the main tree using the same paint but darker. Repeat the process and work over the tree at the back.

Finished stage Mix Hooker's Green No. 1, Yellow Ochre, Crimson Alizarin and a touch of French Ultramarine,

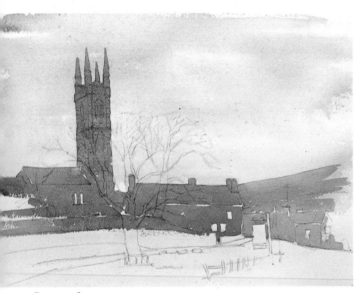

First stage

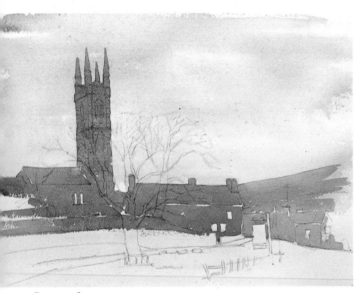

Second stage

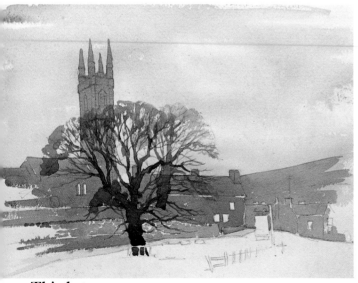

Third stage

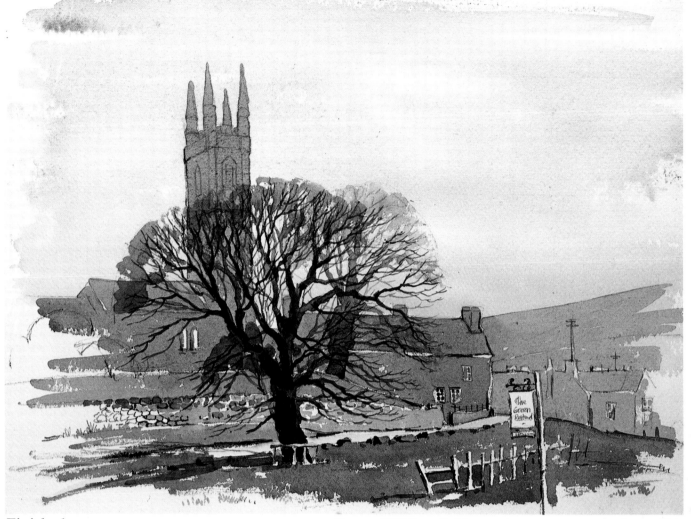

Finished stage

Greens RWS 140lb Not surface, 27 × 37cm (10½ × 14½in)

and now with your size No. 6 sable brush paint in the foreground field leaving the fence area as white paper. Next paint in the windows using the same colours without Hooker's Green No. 1, and paint little blobs to suggest

windowpanes. Put more work into the wall, by drawing some stones with your brush, using the same colour as for the windowpanes. Now work on the foreground tree again making it darker and put in more small branches. Now using dark colour put shadows on the white fence and signpost and add accents where you need definition. The sketch must be good enough for you to refer to and understand, when you no longer have the scene in front of you. Finally, using French Ultramarine, Crimson Alizarin and Yellow Ochre paint in the shadow of the tree.

EXERCISE SIX
PASTEL

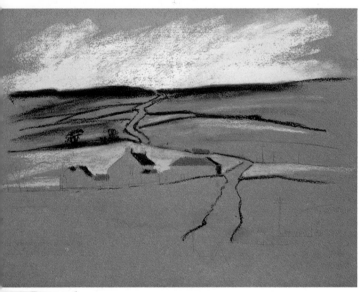

First stage

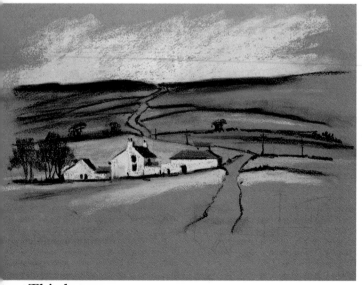

Second stage

Third stage

When you are out sketching a scene like this farm on the moors it can easily be overlooked. If the sun is out and everywhere is bathed in bright light, the farm can look flat and uninteresting; and if it is a dull overcast day, then you could miss the farm altogether as it would merge into the grey background. The best time to see a scene of this kind is when there is sun around with clouds casting large shadows over the moorland, adding drama to the picture. Unfortunately, a sunlit farm like the one in the sketch, does not stay like that for very long – anything from one to 10 minutes. However the clouds are moving all the time so soon you would see almost the same effect again. Once you have been inspired, start your sketch and catch the effect you want. Try to train yourself to remember the scene, and the more you sketch the easier it will be.

First stage Draw in the main features with a 2B pencil. (If you were outside and working quickly, you might find you could go straight in with pastel, without doing any pencil drawing.) Now using Yellow Ochre Tint 2 on its side (the long edge) paint over the sky area in broad strokes from left to right. In the same way paint Cobalt Blue Tint 2 over the top, leaving the area by the road clear, and smudge the colours together with your finger. Now with Green Grey Tint 6 paint in the distant hills and draw in the hedges of the fields and road.

Second stage Work Burnt Umber Tint 4 onto the distant hills and rub it in with your finger. Now work in the fields down to the farm, using first a little Yellow Ochre Tint 2 and then Sap Green Tint 3 on the distant fields, painting it stronger down towards the farm. Rub in the colours to tone down the area. Next paint in the farm roofs with Purple Grey Tint 4, and work over the shadow side (on the right – the sun is left) with Green Grey Tint 6.

Third stage Paint in the sunlit walls of the buildings with Yellow Ochre Tint 2, and use Green Grey Tint 6 to paint in the dark wall in front of the buildings. With the same colour pastel, paint in features of the farm such as, chimneypots, windows, doors, and the trees on the left-hand side. Then smudge in the trees with your finger. Paint in the foreground field using Lizard Green Tint 3 up to the shadow area, then work in some Burnt Umber Tint 4 up to the farm wall and into the green field. Smudge some Green Grey Tint 6 into the farm building here and there, and into the field on the left. Now with Burnt Umber

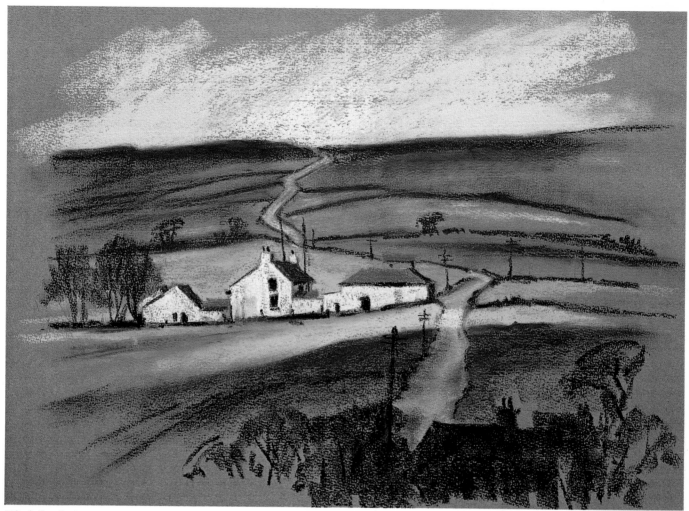

Finished stage Ingres paper, 27×37cm ($10\frac{1}{2} \times 14\frac{1}{2}$in)

Tint 4 paint in the field behind the farm on the right-hand side. With Green Grey Tint 6 paint in the hedges smudging some of the colour across the field. Finally put the telegraph poles in the background.

Finished stage Using Yellow Ochre Tint 2 paint in the road, from distance to foreground and smudge it in to tone it down. Now with Green Grey Tint 6 paint in the shadow on the foreground field. Next paint in the shapes of the buildings, telegraph poles and trees in the foreground with Ivory Black and add a little to the shadow area of the field. Use the black in various places on the farm buildings to crispen it up and, finally, paint over the road where the sun is shining with Yellow Ochre Tint 2.

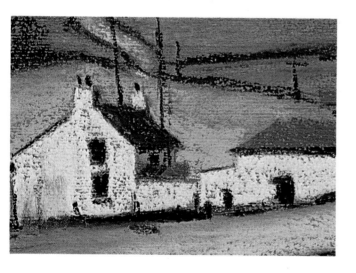

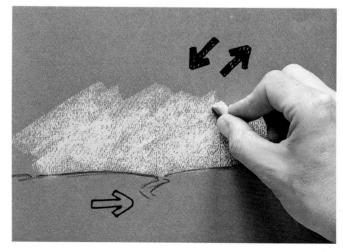

USING YOUR SKETCHES AT HOME

One of the rewards of having sketches that have been drawn outside is you can use them to work on larger paintings at home. There are many reasons for not being able to go out to sketch. The most obvious is the weather, or more frustrating, the car won't start! Whatever the reason if your sketchbooks are full you always have information to work from and something to inspire you.

When searching through my sketchbooks for sketches to reproduce in this book, I was able to relive many happy moments, just by looking at them. There were sketches that I had never worked from and some were up to eight or nine years old! After so much time had gone by I was able to see them in a different context and wanted to paint from them straightaway. I love to come across an old sketch and paint from it in watercolour. It gives me an opportunity to try out different techniques and to illustrate nature's changing moods. An advantage in working from the same sketch is you get to know the subject so well that you can concentrate more on the painting, rather than drawing.

Fig. 71 This is my original pencil sketch which I drew outside and have used as reference to do three paintings at home in watercolour showing the same scene in different moods

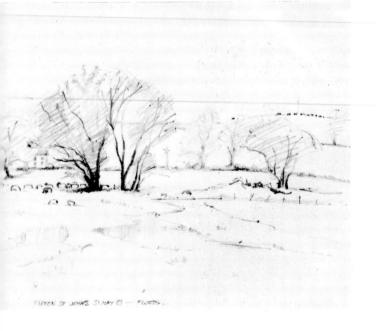

TIPTON ST JOHNS 31 MAY 81 — FLOODS.

Always sketch when you have the opportunity. It is easy to be lazy and put off doing a sketch. When I go on a journey, whether it is for sketching or not, and I see something that inspires me I have to fight against putting it off until later. It is usually disastrous to postpone doing it. When you see the subject later, it may look completely different, the light will have changed or the sun will have gone in and you may decide it is no longer worth sketching. Also you may not go back the way you came, and you wouldn't see the subject again! There is only one way to fill your sketchbooks: keep one with you all the time and when you see something that inspires you, *sketch it*.

It is not as easy as it sounds. Even a professional artist can have difficulties. If you have a family, you can't always stop just when *you* want to. But if you make *the effort*, that is a good start and you will soon see your sketchbook pages gradually fill up with information. When you go on holiday, pack a small sketchbook and I am sure you will find time to sketch. It's a lovely way to bring back memories of a happy holiday. I think I have made my point now: sketch, sketch and sketch, and enjoy it.

The sketch in **fig. 71** is one I did a year ago when there had been a lot of rain and many fields were flooded. (I did take my wellies!) I decided to use this sketch, which I hadn't worked from before and paint it in watercolour showing the same scene in three different moods. All three were painted on the same size paper: 23 × 29cm (9 × 11½in). The first one (**fig. 72**), I painted as I remembered it. I worked on Greens RWS watercolour paper Not surface 140lb, as I did for the other two. I kept the painting simple, to create the feeling of freshness one gets after a rainfall. Notice how the water is painted very simply, with the foreground left as white paper.

For the second painting (**fig. 73**) I imagined it was early morning with a heavy Devon mist. This I achieved by wetting the paper and running the first wash over the whole area leaving only one or two areas of paper white, to represent the water, as well as the house. When it was dry, I added a second wash of colour, and then worked the dark area under the trees.

The third (**fig. 74**) is a snow scene. I painted the sky dark with Payne's Grey, Yellow Ochre and Crimson Alizarin. Using the same colours I 'drew' the picture with my No. 6 sable brush. The secret of this effect is in what you don't paint, for instance, I left plenty of white paper showing through to represent snow.

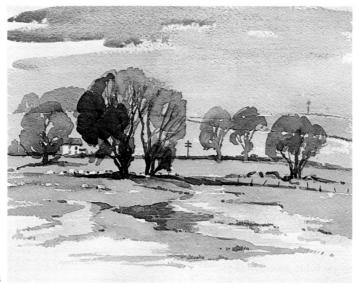

Fig. 72

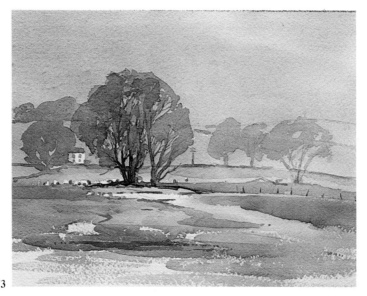

Fig. 73

Fig. 74

A SPECIFIC SKETCH

I decided to write an account of this day out sketching as it embodies all the problems of a specific sketch, particularly the need for careful planning. At the beginning of the book I explained what a specific sketch was and described the ones you are most likely to come across. But if you are ever in a situation that *demands you get it right the first time*, which can be a sketch of, say, the local summer fete, a gymkhana, or even the Derby, then I hope my account of this exceptional experience of working a specific sketch in front of television cameras can help you.

I had been asked by the BBC if they could film me on location painting a watercolour and broadcast it on their feature programme *Spotlight South West*. Naturally I was thrilled and excited to be asked, but then I became very nervous and agitated as it gradually dawned on me what I had agreed to do. It would entail working outside (at the mercy of the elements); painting a scene that the camera could see also – and in watercolour (as you know watercolour has a tendency to do what *it* wants to, especially when there is an audience!); and describing what I am doing as I paint. It was going to be a totally new experience for me. I had been on television before to be interviewed live, but this was going to be very different.

I met Peter, the director of the film, at my studio to discuss the details and, from the moment he arrived, he put me at my ease and my anxieties faded away. The brief was simple. I was to work by the river in my local village, and a day was arranged. Then it was up to me to work out *my* plans.

My photograph of the scene I painted for the television cameras

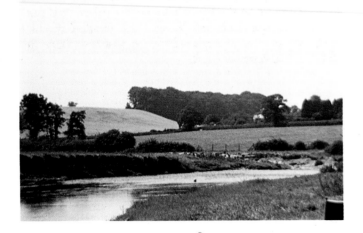

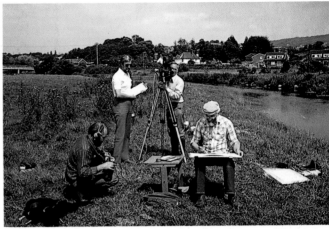

The photograph that, my wife, June took of the BBC crew filming me sketching on location

I decided to go down to the river the day before filming and find a suitable spot. But there were certain restrictions. It had to be near the village car park, as equipment had to be carried along the river bank: cameras, sound equipment, and so on. The scene had to include the river and the subject had to be simple so that viewers could see it clearly and I would be able to describe what I was painting. I also had to be in a position that would enable the camera to work behind me. When I looked around I found plenty of perfect scenes, but the camera would have had to have been in the river!

This day was to be a trial run and I checked my equipment thoroughly. I used Greens RWS Not surface watercolour paper, 38 × 56cm (15 × 22in); I had four sheets on a board and I took a small fold-up table to put my paints on. I don't take it out with me normally, but it was the only way for the camera to see me mixing my paints. I took pencils, paintbox, brushes, rubber, water and a container, and a knife for resharpening pencils. I always carry plasters in my bag, in case of cuts; it might sound over-cautious, but if you cut your finger getting over a fence or on some brambles, it's not very convenient if you are miles from home. I also took my sketching chair.

The only factor I couldn't control was the weather, but the morning of the rehearsal was glorious. The sun was in a clear blue sky and it was warm. June came with me and we walked down the river bank searching for the best spot. As in any specific sketch there are immovable or unchangeable factors to overcome. Eventually after about three hours of wandering up and down trying to meet all the requirements, I decided on one scene and held another in reserve. It was a tremendous relief. At that point I was very hot and it was also lunchtime, so June and I went to the village inn to sit outside and have a quick lunch. (Incidentally, the inn is the one sketched in Exercise Two.) Feeling more relaxed we then returned to the spot I had marked with stones, set myself up and started to paint.

After an hour's painting it dawned on me that the subject was not right for my purposes. Reluctantly, I

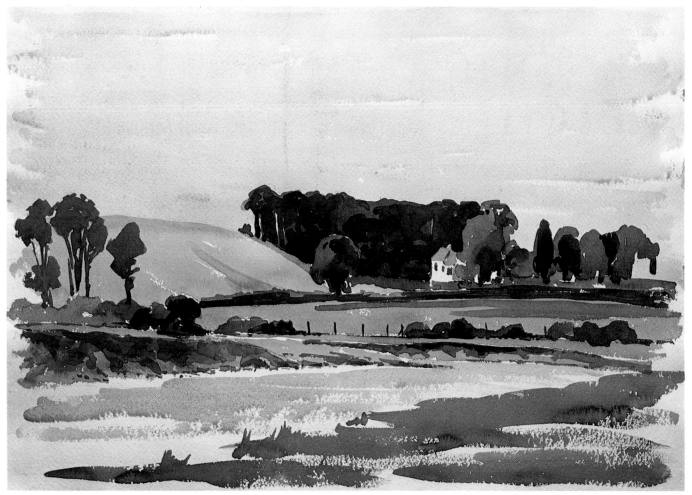

The finished watercolour sketch that I did while being filmed, 39 × 56cm (15½ × 22in)

stopped, feeling very annoyed with myself, and June and I went to the second spot. I set myself up again and started a new painting. I had only been working on it for about half an hour when that gorgeous feeling came over me that 'this is the one'. It was the perfect scene, how I came to put it in second place I shall never know, but it was lucky I had planned in advance or the film would have covered the first painting. While I was painting I worked out in my mind how to break up the various stages: where to stop and start (or, more important, where I could *not* stop) for the cameras the following day. I finished the painting and was very pleased with it.

The following morning my only worries were the weather and whether the cows would be in the field we were working from! In the event the weather was even better than it had been the previous day, and when I went down to the river early, there were no cows! The day was set. Peter arrived and we went down to the village to meet the cameraman and the sound engineer. We all set off carrying our equipment down the river bank. Clinton, my 12-year-old son, was on half term and he came along too. It was such a beautiful day it felt as though we were all going for a picnic down by the river. When we reached my marker of stones, I set up my equipment.

I had been through the experience before and I felt at

home – but not quite relaxed. Once everybody was ready and it was explained how I was to start, I got over my first faltering sentences and carried on. The weather was glorious and we went through the whole day without a hitch. I am sure that this could not have been done without my planning and, of course, the professionalism of Peter and the crew. It was a happy day, as sketching should be, and one that will go down in memory lane.

A week later when the film had been edited, we saw the programme and for the first time in my life, I could actually see myself working. There were fabulous close-up shots showing the brush mixing colours on the palette and putting washes over the paper. When I had watched the film I felt very pleased and relaxed for the first time since the BBC's initial telephone call.

DO'S AND DON'TS

TACKLE SIMPLE SUBJECTS
AT FIRST

LEARN TO OBSERVE

BUY THE BEST EQUIPMENT YOU
CAN AFFORD

LOOK CAREFULLY AT YOUR SUBJECT
BEFORE YOU START SKETCHING

PRACTISE USING YOUR PENCIL

NEVER THROW A SKETCH AWAY

WHEN SOMETHING INSPIRES YOU —
SKETCH IT!

DO NOT PUT NOTES ON A
WATERCOLOUR SKETCH

CARRY A SKETCHBOOK AND PENCIL
WITH YOU AT ALL TIMES, AND
SKETCH AS OFTEN AS POSSIBLE

ENSURE THAT YOU ARE
COMFORTABLE AND WARM
WHEN SKETCHING

PUT PLENTY OF COLOUR NOTES
ON YOUR SKETCH

MAKE SURE YOU DRAW ENOUGH
INFORMATION ON TO
YOUR SKETCH

AND ENJOY YOUR SKETCHING —
IT MUST BE FUN!